Y0-CAV-047

Photography and Time: A Special Millennium Issue

Why do we remember the past but not the future?
—Stephen Hawking

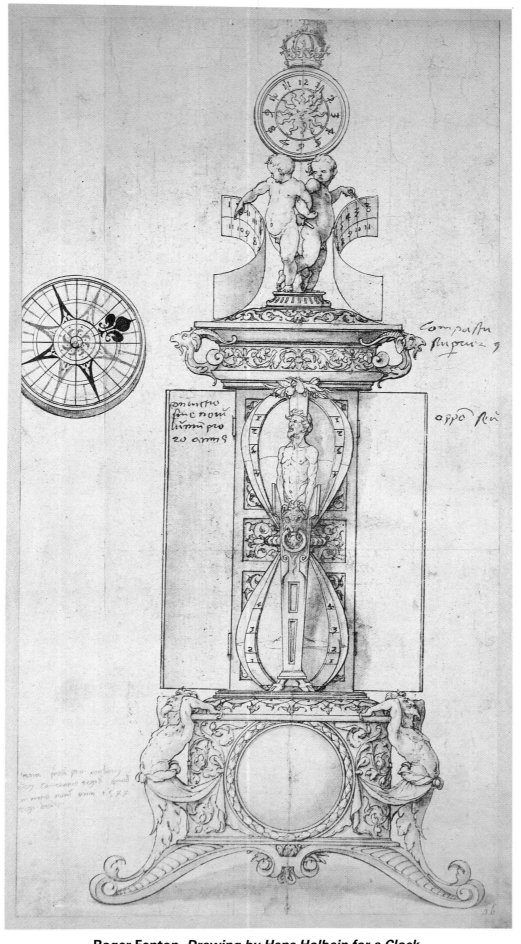

Roger Fenton, *Drawing by Hans Holbein for a Clock,*
British Museum, 1858; *contents*: **Koishi Kiyoshi,** *Drunken Dream Fatigue,* **1936**

Introduction

This publication represents one in a line of collaborations between two institutions—The Victoria and Albert Museum, London, founded in 1852—and *Aperture,* which is nearing its 50th year. Neither the magazine nor the V&A exhibition on the subject of time concern themselves, except incidentally, with great historical events. Time is with us and affects us in much more intimate, personal ways—and photography has proved to be the medium of choice in capturing such moments and metaphors. This is our subject.

William Henry Fox Talbot, the inventor of positive/negative photography, wrote beautifully in 1839 about the medium he invented and its astonishing ability to fix shadows: "The most transitory of things, a shadow, the proverbial emblem of all that is fleeting and momentary, may be fettered by the spells of our *'natural magic,'* and may be fixed for ever in the position which it seemed only destined for a single instant to occupy." Talbot's fascination with transience has been explored by many of his photographic heirs—from his kinsman John Dillwyn Llewelyn, whom we feature here, to his living spiritual descendants whom we also present in this issue.

From the beginning, the inventors saw the new medium as having a major role in preserving works of art and architecture. Opposite is a photograph made by the British pioneer Roger Fenton for the British Museum, of a drawing of a clock designed by Hans Holbein in the sixteenth century. Carefully printed, washed, and gold-toned, Fenton's albumen-silver photograph gave the ancient drawing a new, vivid, and prolonged life, as well as broader exposure. Printing is sometimes romantically termed "an art preservative of all the arts": photography can be described in the same way. The theme continues in the inspired series made by Andrew Bush in an Irish country house in the early 1980s: only Bush was preserving a way of life as well as the house that contained it.

A second theme is the appearance of timepieces of all kinds in Western societies, and the way photography has captured them—from Big Ben rising above the Palace of Westminster to make London tick in 1867, to Josef Koudelka's ominous wristwatch hanging above Wenceslas Square at the time of Prague '68.

A related theme is the photography of everyday life. Photography has existed for most of its 160-odd years outside the academy and it has been used for lowly but essential tasks—none more ardently nor more prolifically practiced than the snapshot. Photography became the medium with which generations sought to measure and mark the important moments of common life, from courting to weddings, new births to maturity, funerals to commemorations.

The photographic work that revealed the machinations of time was produced by the acknowledged masters Eadweard Muybridge and Dr. Harold E. Edgerton. New light is shed on them by photo historian Phillip Prodger and by Edgerton's former colleague Gus Kayafas. And then, of course, we present the work of artists who explore time, who reimagine it, reconfigure it, find new metaphors, play new games, and slow us down—or speed us up. Two of the remarkable, fecund themes here are water and light—how they appear again and again as images of time. One does not need to be a Heraclitean philosopher to find these images poignant in relation to time—its passing, endless flowing and paradoxical promise of eternal inspiration. —Mark Haworth-Booth

The Llewelyn Album

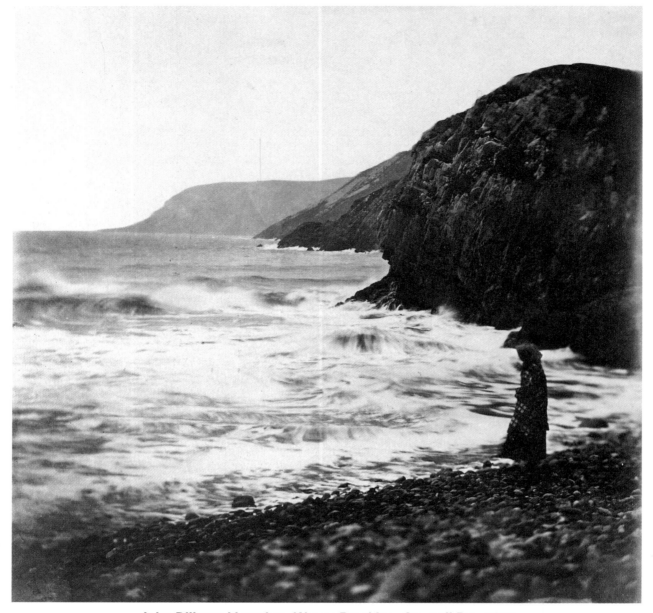

John Dillwyn Llewelyn, *Waves Breaking, Caswell Bay*, 1853

The Welsh photographer John Dillwyn Llewelyn was in many ways a modern, or at least a pre-modern. More than other early photographers, he was interested in photographing time. He made perhaps the earliest successful exposures of such fleeting events as waves breaking. He photographed clouds and made a spectacular photograph of a ship exuberantly blowing off steam. These were astonishing setpieces, which Llewelyn exhibited to acclaim in London and Paris. He sent four images on the theme of motion to the Exposition Universelle in Paris in 1855. The judges awarded him a silver medal, a very high honor. He and his wife Emma and sister Mary did something more, however, that attaches them to us. They photographed daily life—or rather, those not quite daily things we like to catch in passing and remember, such as an elaborate picnic, or a day at the seaside. They also made quick, animated family snapshots. They photographed regularly, at times

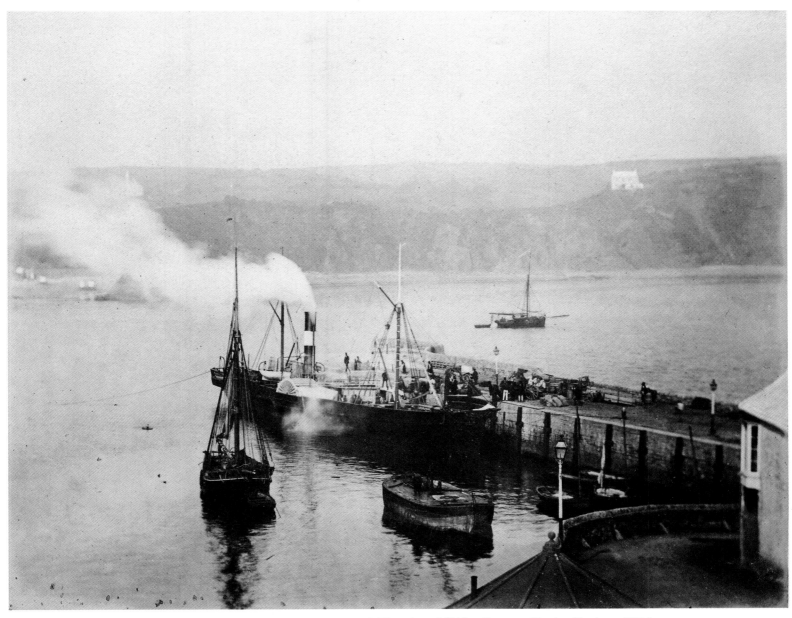

John Dillwyn Llewelyn, *"The Juno" Blowing Off Her Steam, Tenby Harbor*, 1854

almost daily. The photographs here are all from a family album, begun by Bessie Dillwyn in 1853, which is now in the collection of the Victoria and Albert Museum.

Llewelyn and his family were unlike most of us, of course, in that they were simultaneously wealthy, intellectually gifted, and socially well-connected. They learned photography from the man who invented it—at least the positive/negative version, which is the one that counts. Talbot was a cousin, so they

learned the process and its improvements virtually as they were made. Llewelyn himself contributed to these advances. He produced a shutter that allowed him to capture the movement of waves at approximately 1/25 of a second. He also found a way to treat collodion plates so that they retained their essential attributes of speed and clarity but could keep for several days. This was an important consideration: to make such photographs as the *Juno* blowing off steam, Llewelyn had

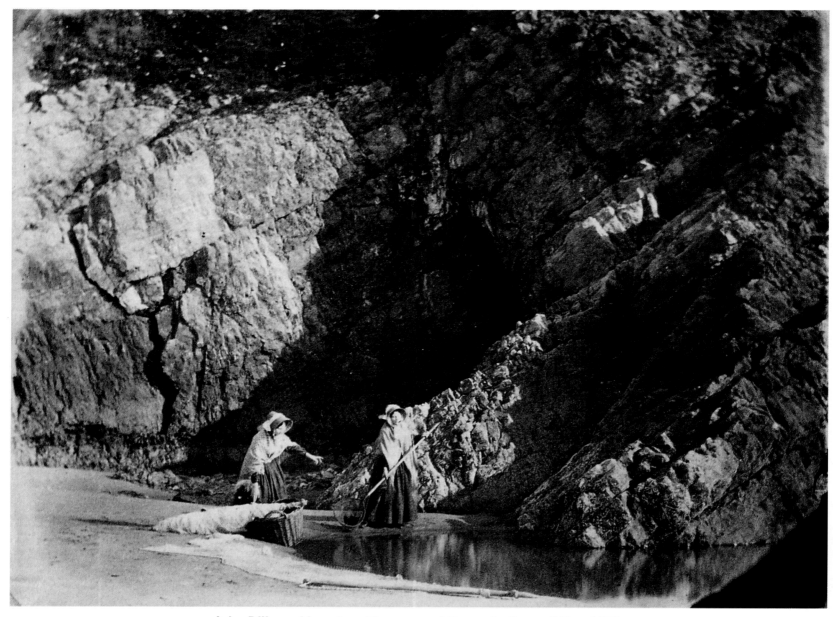

John Dillwyn Llewelyn, *Theresa and Emma in Caswell Bay*, 1853;

to hire a room in Tenby harbor. This was not only to give him a vantage point for his camera but a temporary darkroom for treatment of the negative immediately before and after exposure. He wanted to be able to photograph more spontaneously. Despite the outlay of time and money however, Llewelyn was like most of us in another way: he was an amateur—a true one, who did not photograph for profit.

The Llewelyns photographed to make the most of time. They understood that they lived in a newly revealed and startling dimension, explained by geologists with rocks like the ones they photographed. The fossil record did away with biblical time, proposing immeasurably longer, pre-Christian and even pre-human vistas. Commentators tell us—glibly—that any photograph is a sign of time passed and thus of death. These photographs suggest that the opposite is true. A woman will always stand beside the ancient rocks to watch the dashing waves. Reflections will continue gleaming on the sandy shore.

—M H-B

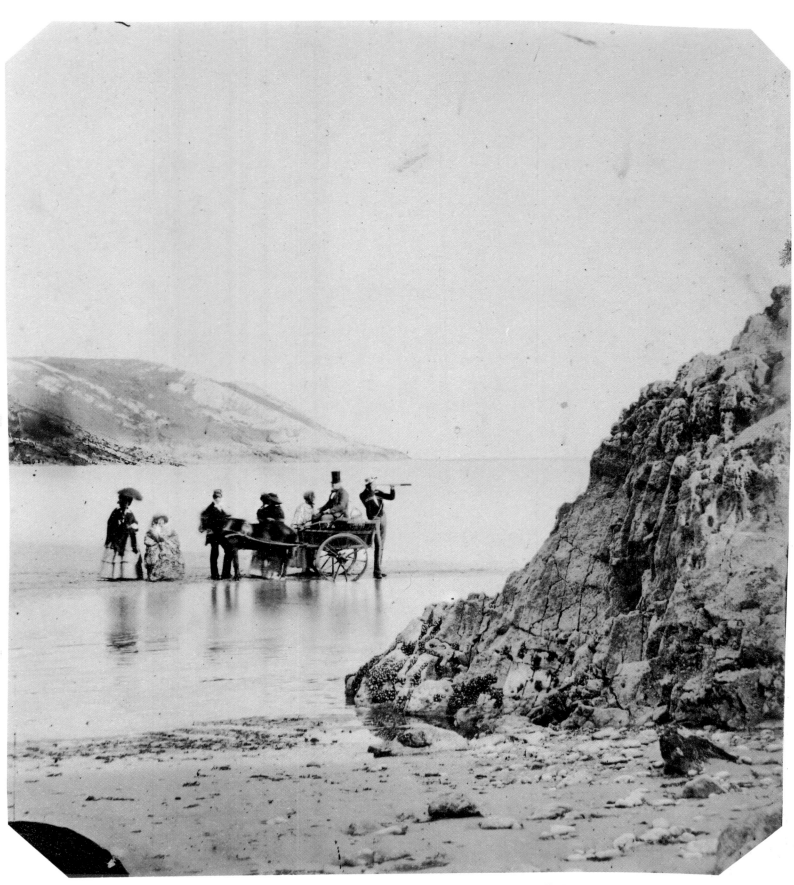

Mary Dillwyn, *The Reverend J. Davis and Family in Three Cliffs Bay*, 1854

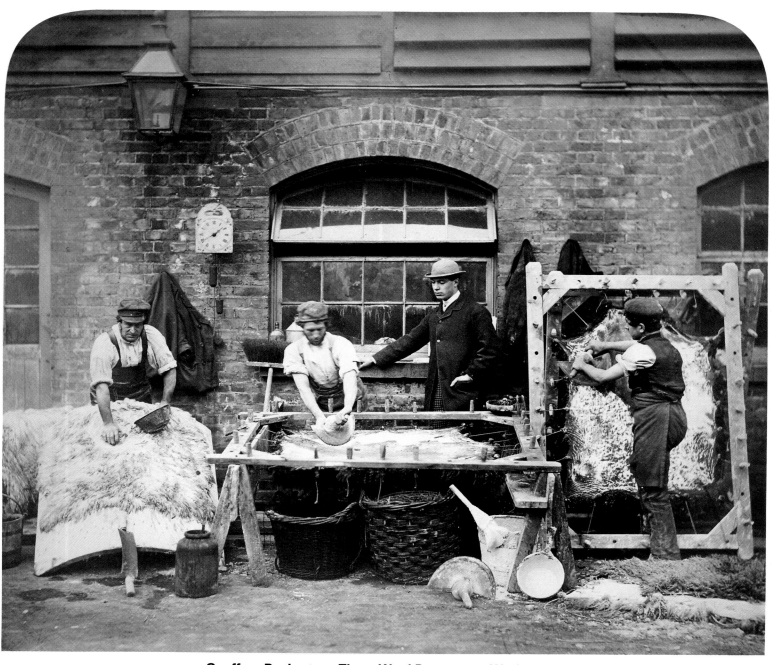

Geoffrey Bevington, *Three Wool Dressers at Work*, 1863

The Industrial Revolution and the factory system that evolved from it imposed a new discipline, sense, and application of time. In Bevington's staged photograph, three phases of rug-dressing—formerly a cottage industry—are shown simultaneously as an efficient production process.

Although the craftman's skills had not yet been replaced by the machine, the process was dictated by the factory clock, which denoted the rate at which you worked, the hours you worked, and the rate you got paid for the job. These ideas were further developed in the twentieth century by an American industrial engineer, Frederick Winslow Taylor, who used photography to study ways of making industry more rational and efficient.

Big Ben symbolizes the political poser of British time even more than Greenwich mean time. Big Ben conflates power over time with political power, in an image that is now part of the physiological image make-up of British identity. —Peter James

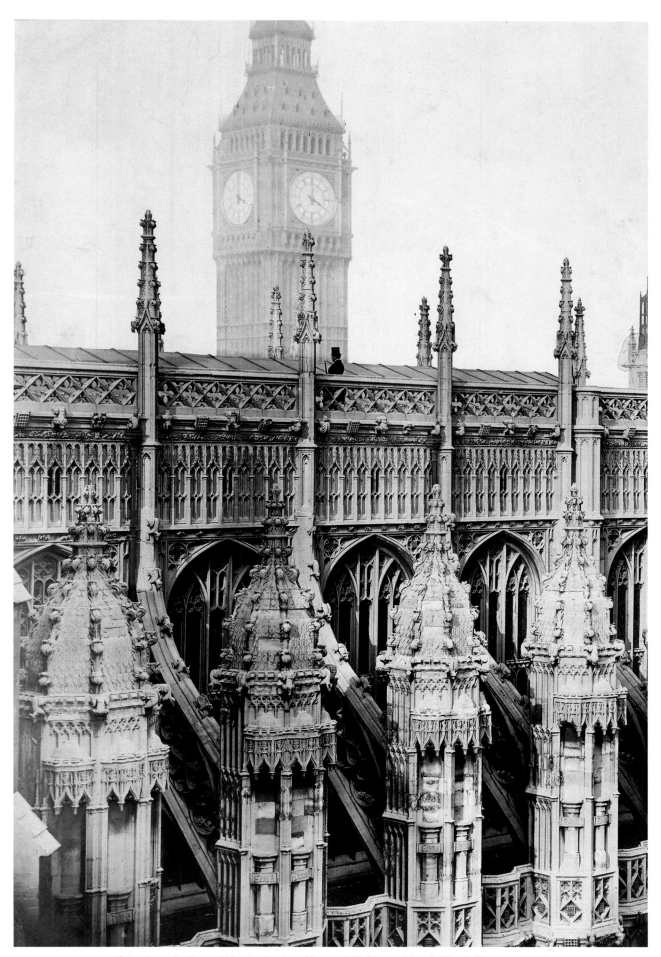

Stephen Ayling, *Westminster, Henry VII Chapel and Clock Tower*, 1868

Edward Fox, *Elm (Winter),* **ca. 1865**

Edward Fox, *Elm (Summer),* **ca.1865**

How Did Muybridge Do It?

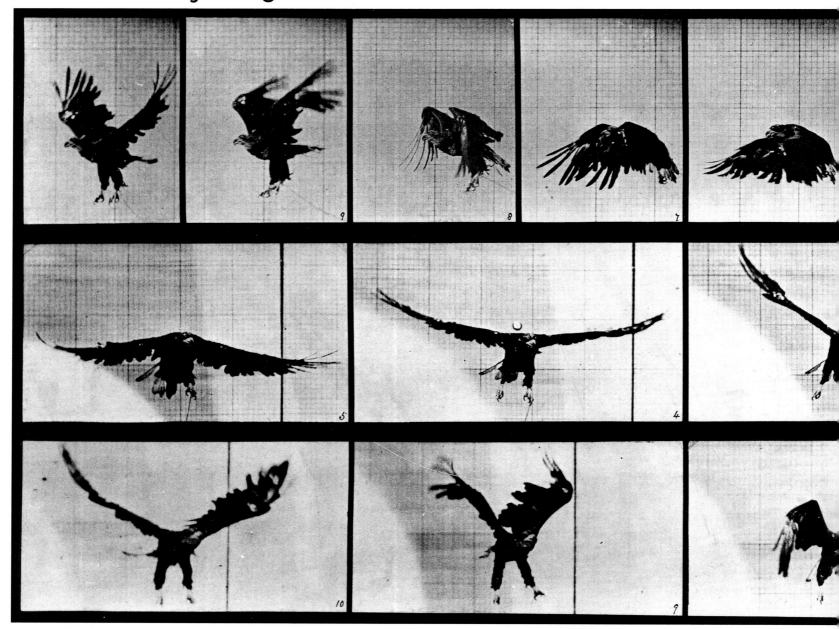

Eadweard Muybridge, *Eagle in Flight*, 1884–86, from the series "Animal Locomotion," 1887

The editors of the *Philadelphia Photographer* declared, in January of 1879, that Eadweard Muybridge's photographs were "enough to turn your brain." "We stretch our imagination to the maximum," they wrote, "and are forced to cry 'stop.'" Muybridge, who besides being a gifted photographer and inventor was an incorrigible showman, relished such reactions.

Emerging from relative obscurity as a landscapist in San Francisco in the 1870s, he quickly became a leading authority on motion photography. His influence was unparalleled: his sequences depicting otherwise ordinary movements became the focus of artistic and scientific debate around the world. The images themselves suggested breathtaking new possibilities for photographic exploration, while the zoöpraxiscope, the device he built to animate his photographs, speeded the invention of cinema. However, as influential as these developments were, they all hinged on a single achievement. Muybridge was the first person to make convincing photographs of small fractions of time.

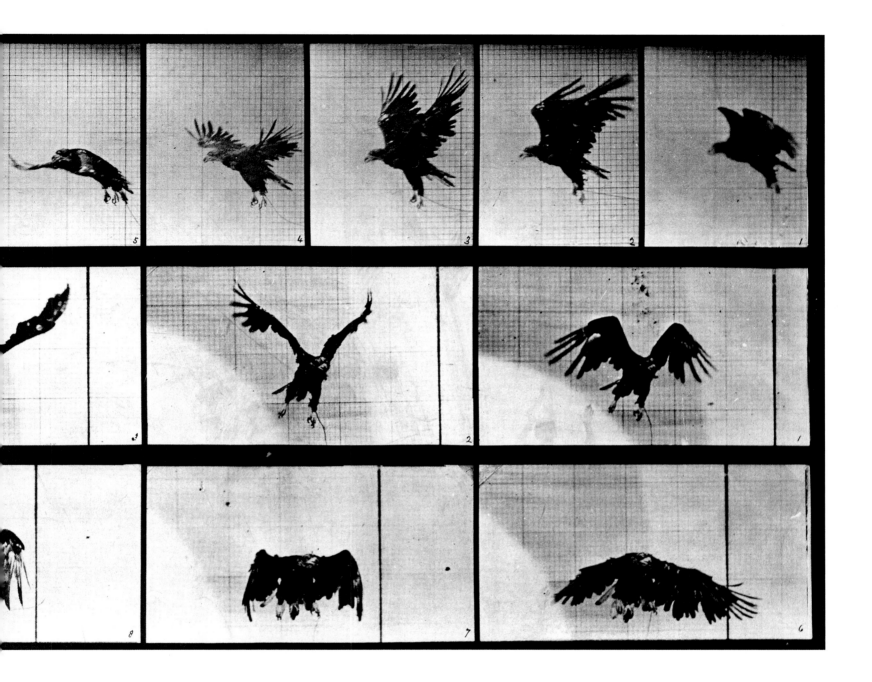

How did he do it? He never revealed the chemical recipe he used to process his negatives, but it is clear that initially he employed the same, slow, wet-plate collodion materials common at the time. Muybridge somehow used these plates to make photographs with extremely short exposures—as fast as 1/1000th of a second, he claimed. Working outdoors in California afforded certain advantages, such as the bright, reliable sunlight that later made Hollywood a center of the movie industry. Former governor and railway tycoon Leland Stan-

ford provided financial backing, including a state-of-the-art set of Dallmeyer lenses, unfettered access to his prize collection of horses, and the assistance of a staff of top engineers.

Muybridge's personal ingenuity is evident in his earliest photographs of horses, taken in Palo Alto between 1872–77. A picture of the horse Occident made during this period, for example, reveals a dimension to Muybridge's creativity that went unnoticed at the time, and has not been commented on since. He appears to have been one of the first

photographers to use panning to capture motion, following the subject with his camera to reduce its movement relative to the plane of the negative. While this resulted in photographs with blurry backgrounds, it also enabled him to produce pictures in which his moving horses were relatively sharp. This technique, though of limited use in still photography, ultimately became one of the defining characteristics of cinema, which he helped to invent.

Although he later abandoned this panning technique, Muybridge excelled at tracking motion. Even using a series of cameras, as he often did in his later work, it was tricky to gauge the velocity of a subject, and determine where to place the cameras to obtain the best results. His sequence of a swooping eagle, made during his residence at the University of Pennsylvania from 1884–86, is a masterwork of anticipation and timing. It not only shows a bird hurtling through space at a changing rate and altitude, it also captures the subtle pivot of the animal's body at the nadir of its descent.

Despite his virtuosity, Muybridge always suffered from credibility problems. One of the most famous of his horse photographs, *Occident Trotting at a 2:30 Gait*, purports to be a photograph of a horse's movement frozen in time. Yet it is not really a photograph. Although sold as an albumen print, it is actually a copy of a drawing now in the collections of the Cantor Center for Visual Arts at Stanford University, itself presumably copied from an indistinct photograph unsuitable for publication. Muybridge acknowl-

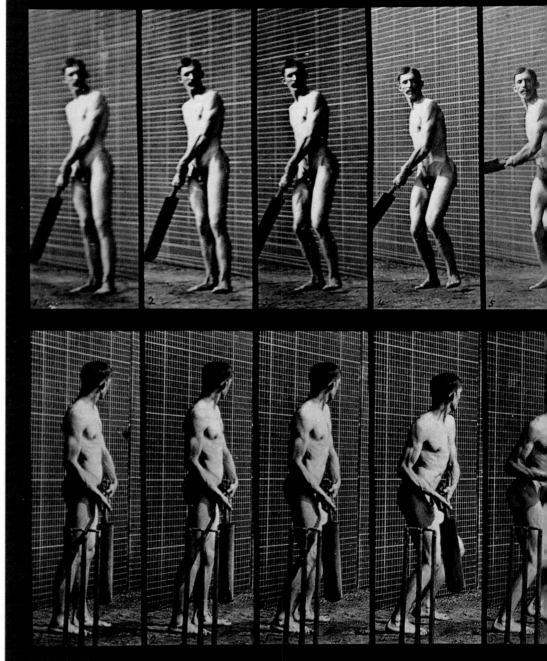

Eadweard Muybridge, *Batsman*, 1884–86, from the series "Animal Loco-

edged on the mount only that, "The picture has been retouched, as is customary at this time with all first class photographic work." The veracity of Muybridge's photographs are often questioned. In a sequence such as the *Batsman*, for example, one must rely on Muybridge's account of how it was made. Nothing about the picture itself indicates time elapsed. Yet human subjects are easy to direct—can we be sure that the man in the

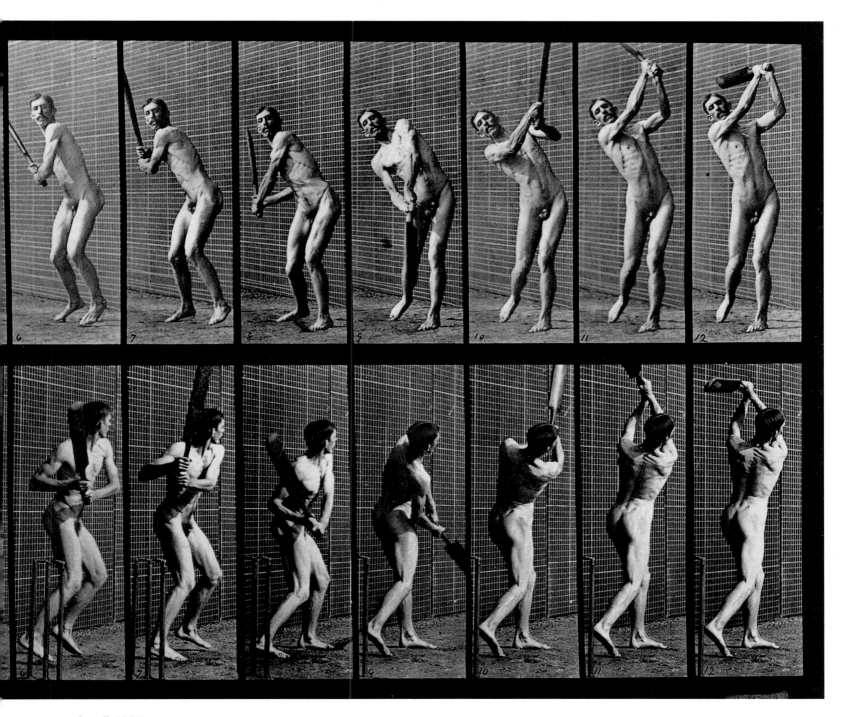

motion," 1887

picture is really swinging a bat at full speed, or has he slowed himself down to enable himself to be photographed more easily? Were each of the frames made in a single session, or were they assembled from separate attempts? Were there additions or deletions? In short, could Muybridge be trusted?

Even in Muybridge's day, not everyone was convinced. William Rulofson, a photographer with whom he had worked earlier in his career, was among those who cried foul. In a letter to the editor of the same *Philadelphia Photographer* that had praised Muybridge's photographs as "brain turning," Rulofson wrote in August of 1878, "Photographically speaking, it is 'bosh;' but then it amuses the 'boys,' and shows ... a fact of 'utmost scientific importance.' Bosh again."

—Phillip Prodger

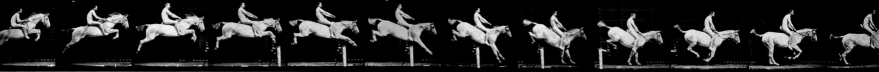

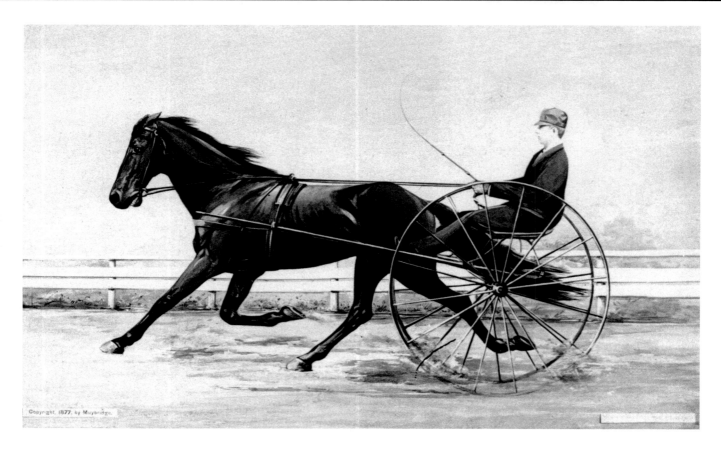

Copyright, 1877, by Muybridge.

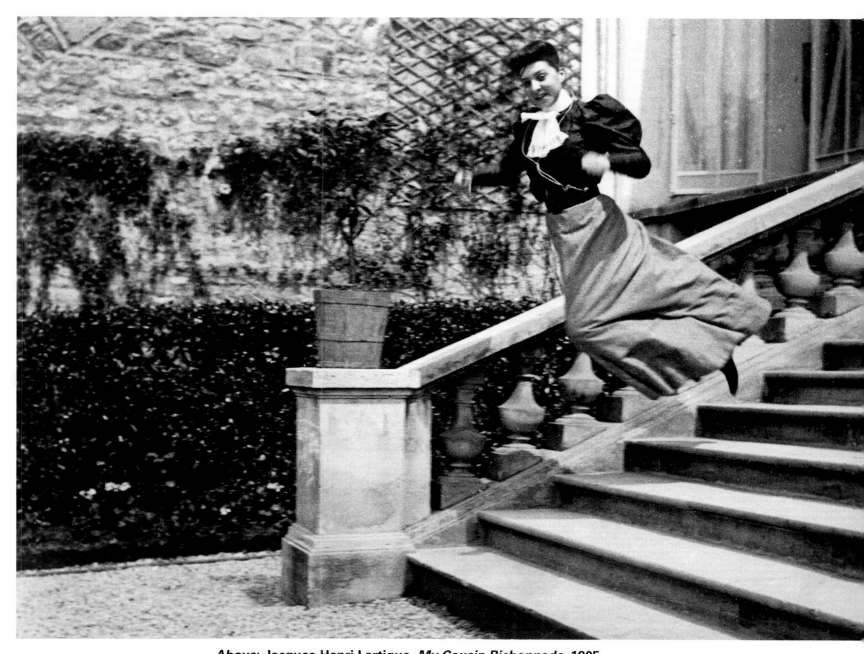

Above: Jacques-Henri Lartigue, *My Cousin Bichonnade,* 1905
Opposite-top: Eadweard Muybridge, *Occident Trotting* (Panning), 1878
Opposite-middle: Eadweard Muybridge, from the series, "Animal Locomotion," 1887
Opposite-bottom: Eadweard Muybridge, *Occident Trotting at a 2:30 Gait,* from the series "The Horse in Motion," July 1877

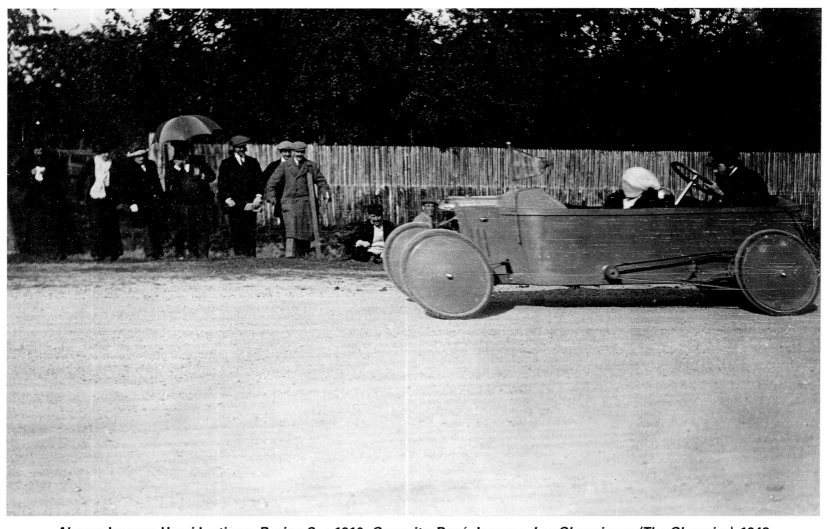

Above: Jacques-Henri Lartigue, *Racing Car*, 1910; *Opposite*: René-Jacques, *Les Olympiques (The Olympics)*, 1948

Jacques-Henri Lartigue grew up surrounded by cars. Many of his most dramatic pictures are of cars in motion. The effect of oval wheels leaning forward seen in this photograph was produced by slightly panning the camera to follow the car and releasing the focal-plane shutter as it did so. The result: an image conveying a remarkable sense of speed and motion. —P J

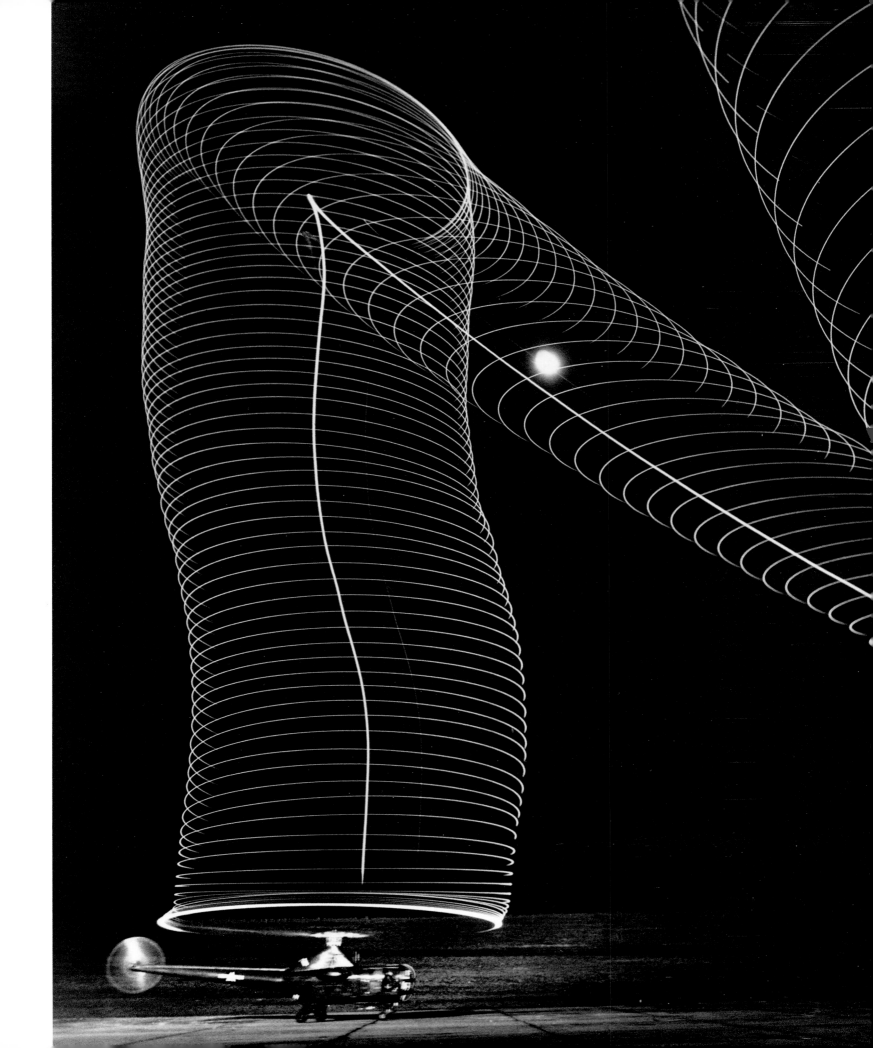

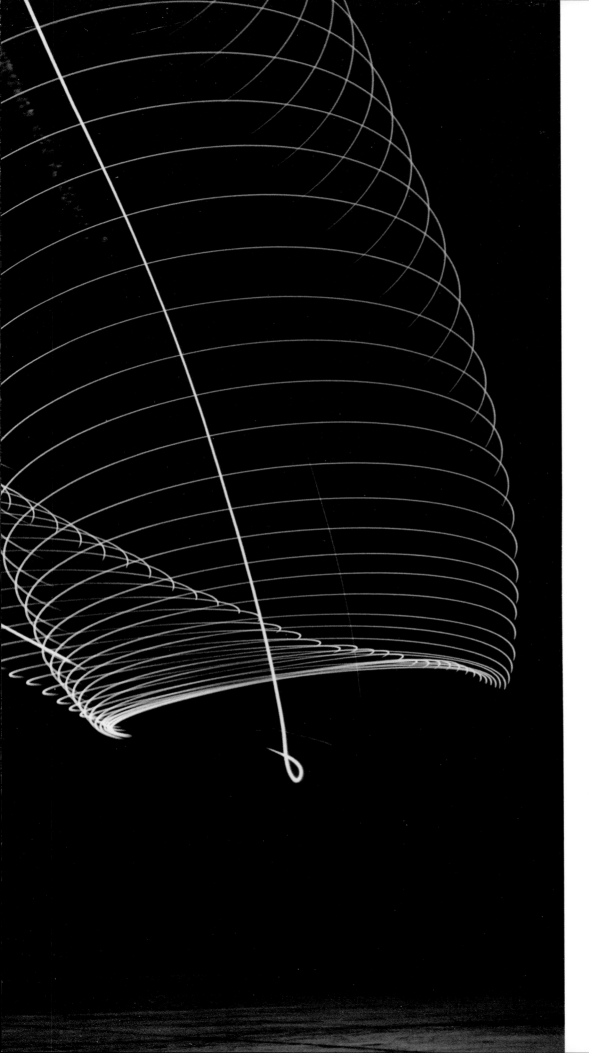

Andreas Feininger,
U.S. Navy Helicopter, 1949

Flashback: The Photography of Dr. Harold Eugene Edgerton

Interview with Gus Kayafas

In 1965 I went to the Massachusetts Institute of Technology [MIT] as a freshman. I arrived a little bit early and while wandering around, I found a gallery. Dr. Harold Edgerton, whom we called "Doc," was always proud of saying he had the only museum that was never closed. He had the two hallways where his laboratories and offices were lined with original photographs—not behind glass—with all kinds of explanations. He was very proud of the fact that they were never stolen but that they were always worn out, because people would rub and touch the print—"look at that shockwave!" and so on.

Photography had been a hobby of mine. I signed up for his course, became his student, and gradually worked with him. Doc and I started printing together, and he and Minor White gave me a job working as a technical assistant at MIT. Then I went to Massachusetts College of Art on the Photography, Film and Video program. When I found out that Doc had paid my salary at MIT out of his own pocket I went to him and proposed that we do a portfolio. This hap-

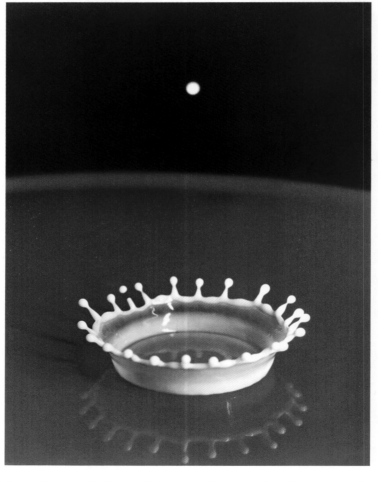

pened in 1976 or '77. After we finished this portfolio we worked on a number of exhibits in art museums and galleries. We formed a partnership, and I began producing editions of his work and arranging many exhibitions. From 1980 until his death in 1990 we worked together often. As we printed the images he would tell me about them.

MILK DROP CORONET, 1957

A layer of milk is first poured onto a surface, and when the drop comes down, it makes that coronet. A long spout comes up, snaps off, the spout comes down, and that drop finally starts to descend. I remember in a freshman seminar somebody complaining, "Nobody else can take a milk-drop picture now that Doc did this." And Doc said, "What do you mean? This isn't perfect yet."

As far as he was concerned nothing was perfect. This picture, of course, has become an icon. The color is actually a red tin of Scottish shortbread cookies. He just wanted a colorful background.

It's an inch and a half circle of milk, two or three drops.

Above: **Dr. Harold Eugene Edgerton,** *Milk Drop Coronet,* **1957;** *Opposite*: *Lead Falling in a Shot Tower,* **1936**

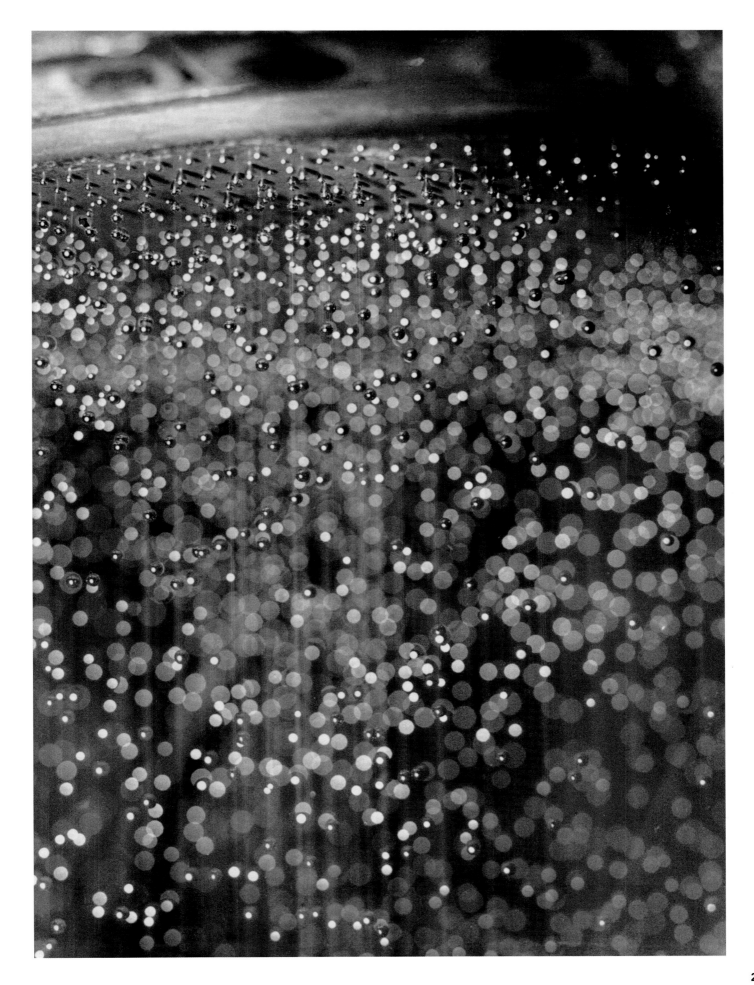

LEAD FALLING IN A SHOT TOWER, 1936

This image was made in a tower for making shotgun shot. That's liquid lead dripping through dies, dropping a hundred feet. As it drops, the lead is formed into a sphere like a raindrop and it solidifies. Doc really loved this picture. He thought this was an arty picture because it was so abstract. There are some prints in which he would crop out of it. In these images there is no way you could tell what the original subject was.

PIGEON RELEASE, 1965

This was shot initially with a 4-by-5 color negative. One of the earlier pictures of a pigeon in flight became known as

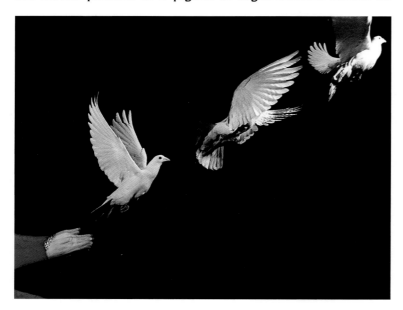

Rising Dove. Doc called it *Pigeon Release*, but some museum curator called it *Rising Dove*—Doc always made jokes about museum curators calling pigeons doves. The earlier version was one of the first pictures the Museum of Modern Art acquired when Steichen was there. About two years later there was a *Harper's Bazaar* that featured this photograph with a child's face in the background looking up, montaged, and it was signed "Steichen." Doc called him up and said, "What the hell are you doing?" And Steichen apologized, "I didn't think you'd mind." And Doc said, "Of course I mind, you took my picture, you put another one in it,

and you put your name on it. That's not right!"

And from that day they became fast and good friends.

MILK DROP SPLASH SERIES, CA. 1935

This was from a high-speed movie camera that Doc invented, which shot 35mm movie film and synchronized with a flash. Instead of stopping and starting, which is what most movie film does, the film just moved through evenly, and as it reached a certain position, the flash fired. The next time it reached that position the flash fired again. So long as the flash was able to recycle fast enough to give you a full charge you could make these photographs of remarkable phenomena. When I found the film I was so excited that there was some footage from which I could make photographs.

This is a series of six exposures. If you look carefully, right at the edge of where the sphere hits the surface of milk you see the reflections, but you also see these little waves starting to form [1]. You'll notice it has serrated crenellations almost like a castle—those evolve into the drops, into the crown. Now you begin to see the crown start to push up [2]. As that drop has hit, all of the energy that was going down has now pushed out. As it pushes out it pushes against the fluid that's already there so a wall of milk arises. Now you begin to see the crown shape [3]. The other thing that's really interesting is that you see the direction of the flash, because of the shadow. Now we have a complete crown, a shadow of the crown, a reflection of the crown, and this surface in the background. If you look at the top edge, you see it has stayed the same through it all [4]. In the next frame the crown has begun to come back down and move back in. You see these concentric rings and these wonderful smaller little spikes [5]. In the final image the surface has been completely changed. It has impacted and spread out so we actually had to move the frame slightly when we made the print [6].

*Above: **Pigeon Release**, 1965; Opposite: **Milk Drop Splash Series**, ca. 1935*

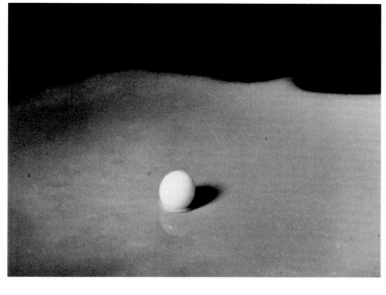 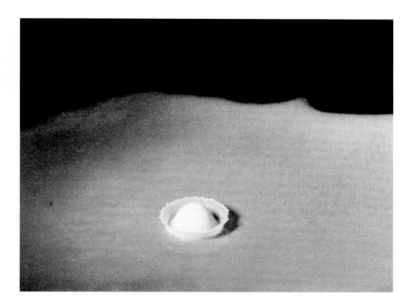

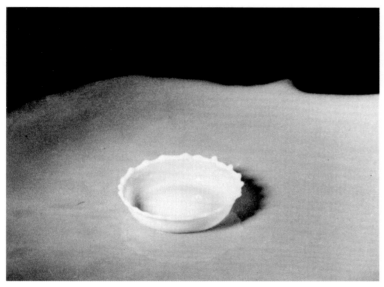 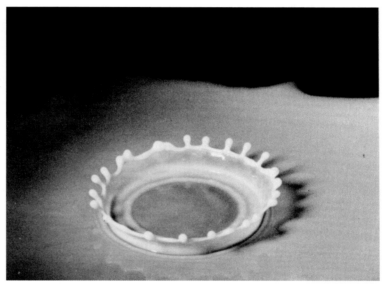

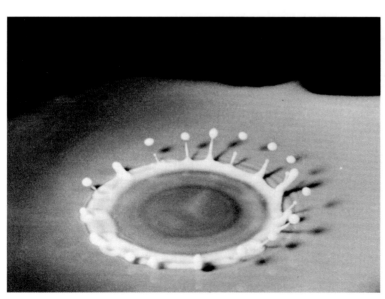 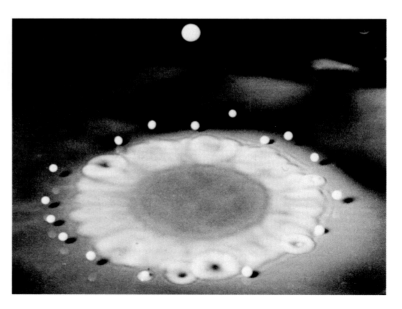

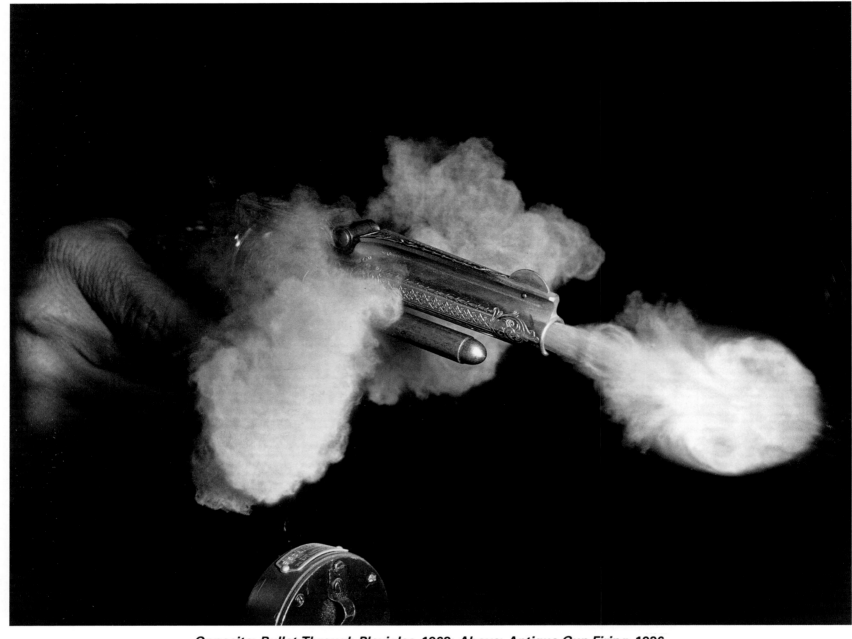

Opposite: **Bullet Through Plexiglas**, 1962; *Above*: **Antique Gun Firing**, 1936

I remember Doc was interviewed for a TV program and he said, "I'm not an artist, I'm a scientist." Afterwards I said, "Of course you're an artist, how many milk-drop pictures have you made?" He said, "Hundreds." I said, "Thousands, I've counted them. Why did you pick the two or three you published?" He said, "Well, those are the beautiful ones." And I said, "Well, that's what art is about; it's not just strategies and concepts, it's about finding that perfect tension between describing some-

thing and making it visible, and somehow still allowing it to be mysterious or beautiful."

BULLET THROUGH PLEXIGLAS, 1962

This is a photogram, a cameraless picture. It's a 30-calibre bullet and you'll notice these black spots at the top right; these are where the bits of Plexiglas actually punched a hole in the film. It was a sheet of 8-by-10 high-contrast film. It's a point-source flash, so just as you get sharp shadows cast by the point

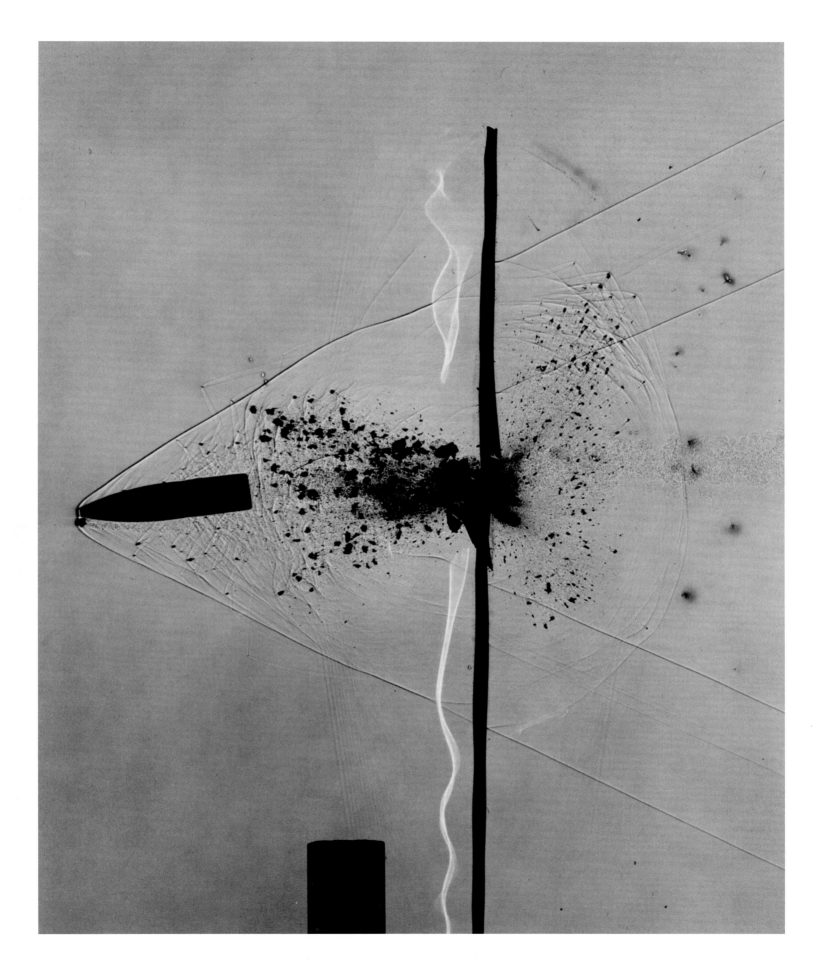

source of the sun, this would cast very sharp shadows. In America, often when you're driving, you'll see a heat differentiation coming off the asphalt and it looks like a mirage, like water because that's the way our brains read it. The light is being bent by that change in the density of the air from the heat, and that's what's happening here. The change in pressure creates the shockwave, and the light actually gets bent, so it ends up not exposing the film evenly. There's a secondary wave of shockwaves, and that's the one that hits the microphone to set the flash off. There is a piece of Plexiglas, in a vise with a microphone, with a bullet going through it. Essentially, instead of a photogram made like a contact print—because this is a point source light—the film is about ten or twelve inches away from what happens. This is something Doc developed during World War II to study projectiles and how they worked. This led to his interest in the speed of sound in different media.

Antique Gun Firing, 1936

This is a late 1800s Colt revolver that a graduate student had. The microphone [bottom of picture] is a really early one. What you see is how much smoke comes out of a gun. It's just all over the place. All of these streaky things here are pieces of glowing embers shooting out of it.

Stonehenge at Night, 1944

Doc was always interested in a visual display that would make people think about amazing things in terms of time, either really short or really long. Probably his favorite place on earth next to MIT was Stonehenge, because he looked at it as the oldest computer. He photographed Stonehenge from wartime on—he made some amazing pictures. He used it as a test site for his airplane flash, which was used to determine where the D-Day invasion was actually going to happen. There were three potential sites for it and they were doing night photography to make sure there was no troop movement. That's how they confirmed Normandy as the location. He got a medal of honor for that.

—interviewed by Martin Barnes

Stonehenge at Night, 1944

Stonehenge: Instruments of Timelessness

A great achievement of neolithic man stands on a plain in England where there is a 360-degree view of the horizon. This configuration of stones, with its massive uprights and lintels has remained an enigma for centuries Many believe that this ancient circle functioned as an observatory for the study of the heavenly luminaries and served a priesthood in arranging an annual calendar of religious ceremonies and festivals. With others attention is focused on the sheer physical accomplishment. But for those who dwell and ponder and look deeper into this magical arrangement there is more. An indefinable force persists and pervades. The effect is to silence one with wonder. These uncompromising stones radiate an awesome prescience. Although the uprights and lintels obviously served as windows and doors one senses a greatness coming through yet another door. A greatness which perseveres in another dimension and causes chronological time to melt away. There is indeed mystery here: of boundaries that unbind and of instruments for the measuring of time which lead to the timeless. We may never know for certain why ancient man assembled these stones but man's humanity can sense the nobility and feel the aspirations that materialized into a great internal idea. Sentinel-like, these stones stand as if encompassing all inner and outer boundaries. Stones uplifted aspiring and balanced. Stones: chanting a ring of protective power for the sacred space within.

—Paul Caponigro, from "The Stonehenge Portfolio," 1967–72

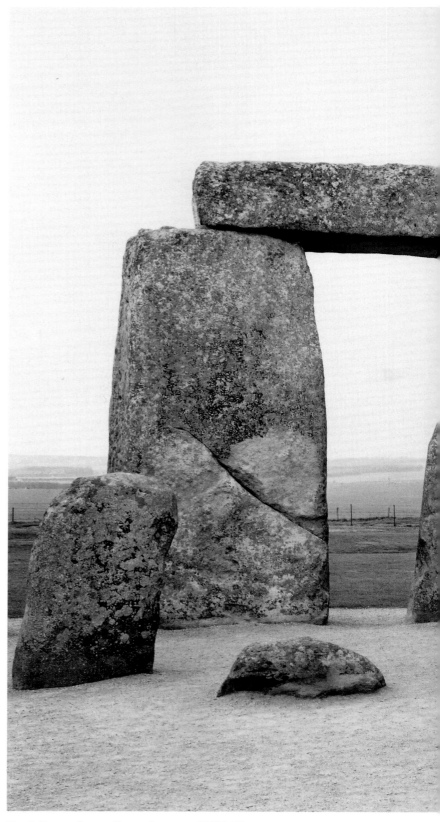

Paul Caponigro, *Stonehenge*, 1967–72

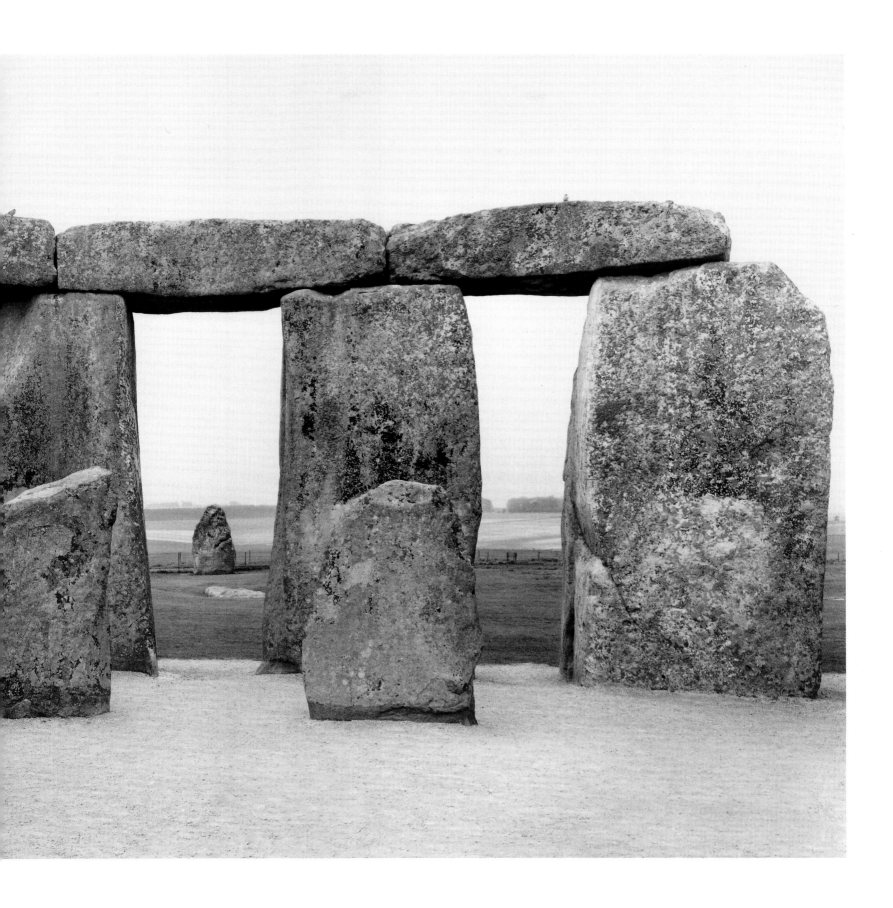

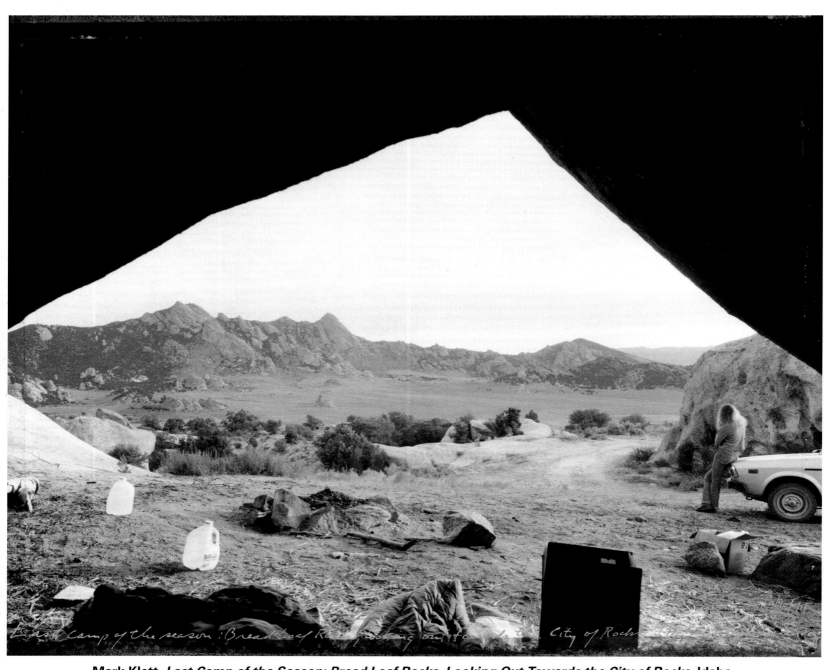

Mark Klett, *Last Camp of the Season: Bread Loaf Rocks, Looking Out Towards the City of Rocks*, Idaho, from the "Rephotographic Survey Project," 1979

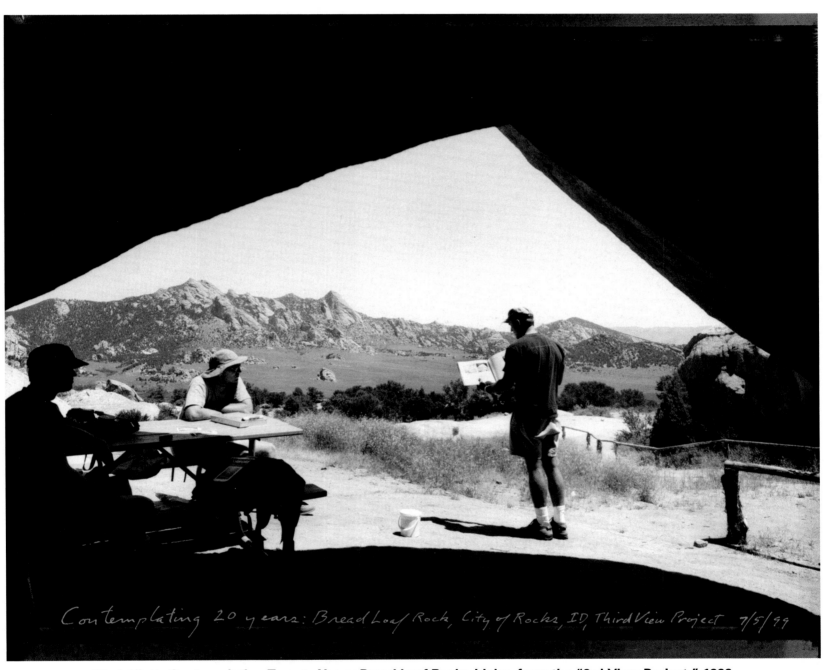

Contemplating 20 years: Bread Loaf Rock, City of Rocks, ID, Third View Project 7/5/99

Mark Klett, *Contemplating Twenty Years: Bread Loaf Rocks,* Idaho, from the "3rd View Project," 1999

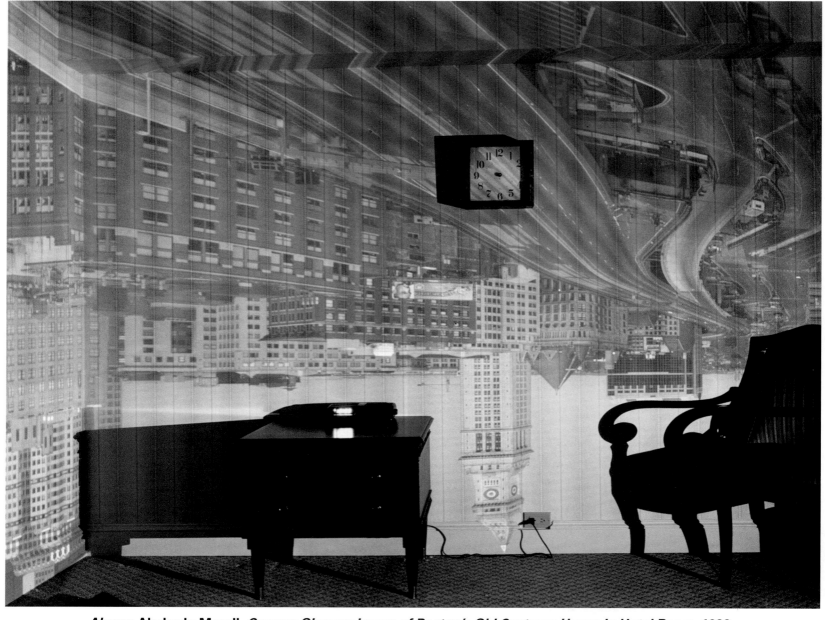

Above: Abelardo Morell, *Camera Obscura image of Boston's Old Customs House in Hotel Room,* 1999;
Opposite: Abelardo Morell, *Water Pouring Out of a Pot,* 1993

In theory one is aware that the earth revolves,

but in practice one does not perceive it, the ground upon which one treads

seems not to move, and one can live undisturbed.

So it is with time in one's life.

–Marcel Proust, from *Within A Budding Grove*

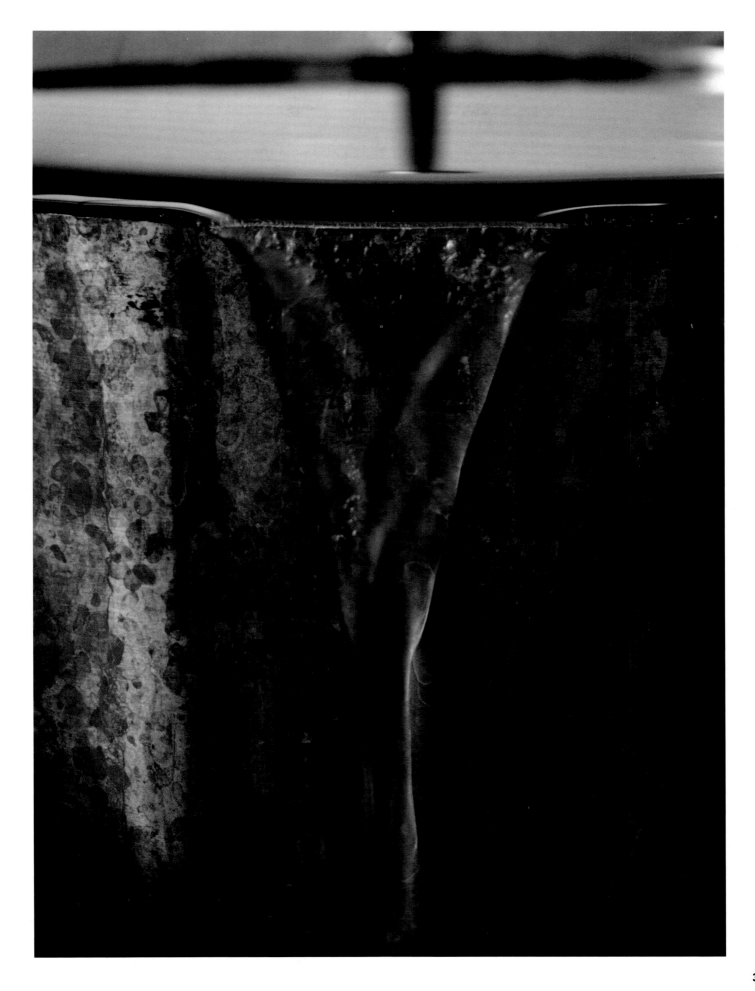

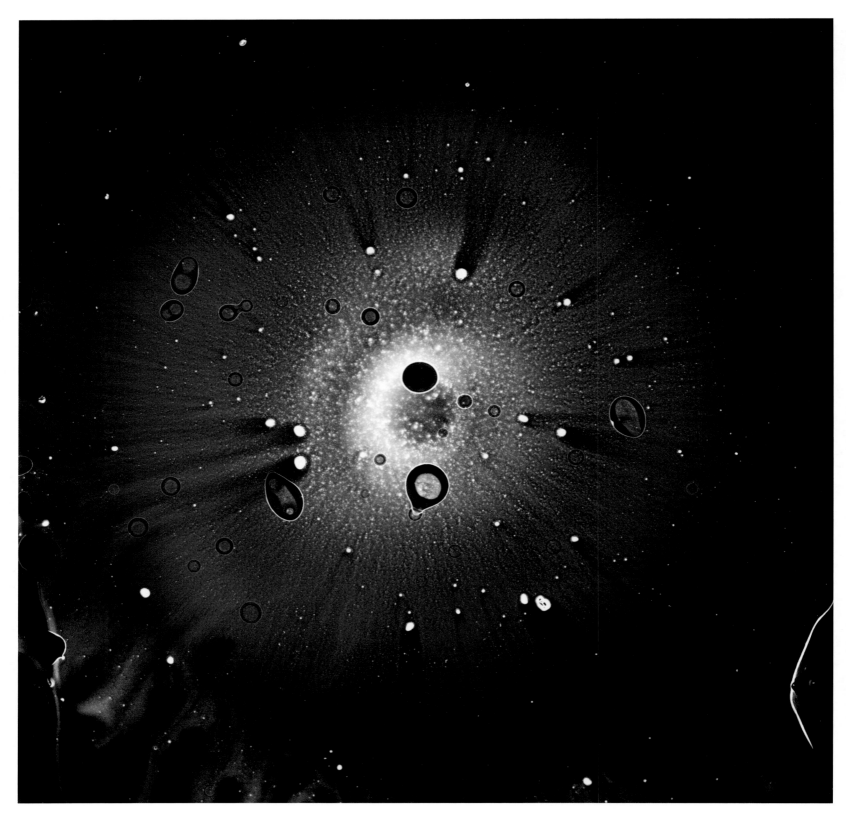

For these cameraless images I introduced carbon into water, creating a mark that is an organic record of the fluid's behavior, both of its own accord and due to my interventions. I work on large pieces of clear polyester and introduce an electric current to enhance the molecular movement of the liquid. Total evaporation can take up to one week, at which time I crop out my "negatives," which are enlarged photographically.

—Charles Lindsay

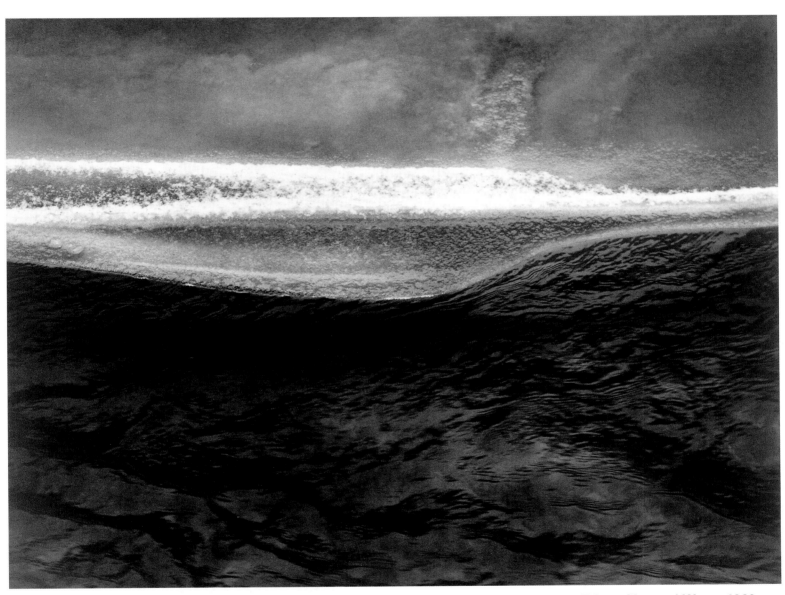

Opposite: Charles Lindsay, from the "Evaporation Series," 1999; *Above*: Minor White, *Edge of Ice and Water*, 1960

Time is the substance

from which I am made.

Time is a river which

carries me along,

but I am the river;

it is a tiger that devours me,

but I am the tiger;

it is a fire that consumes me,

but I am the fire.

—Jorge Luis Borges, from
"A New Refutation of Time"

**Susan Derges, *Rhododendron*,
from the series "The River Taw," 1998**

There is a sacred bond between

slowness and memory, between

speed and forgetting....

–Milan Kundera, from *Slowness*

**Susan Derges, *Waterfall*,
from the series "The River Taw," 1997**

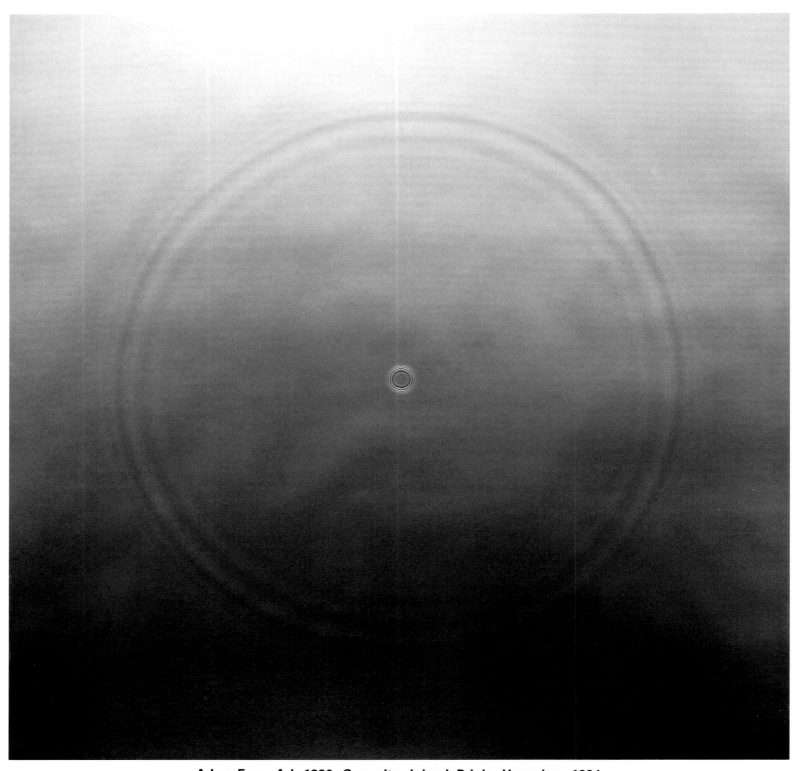

Adam Fuss, *Ark*, **1990;** *Opposite*: **John J. Priola,** *Hourglass*, **1994**

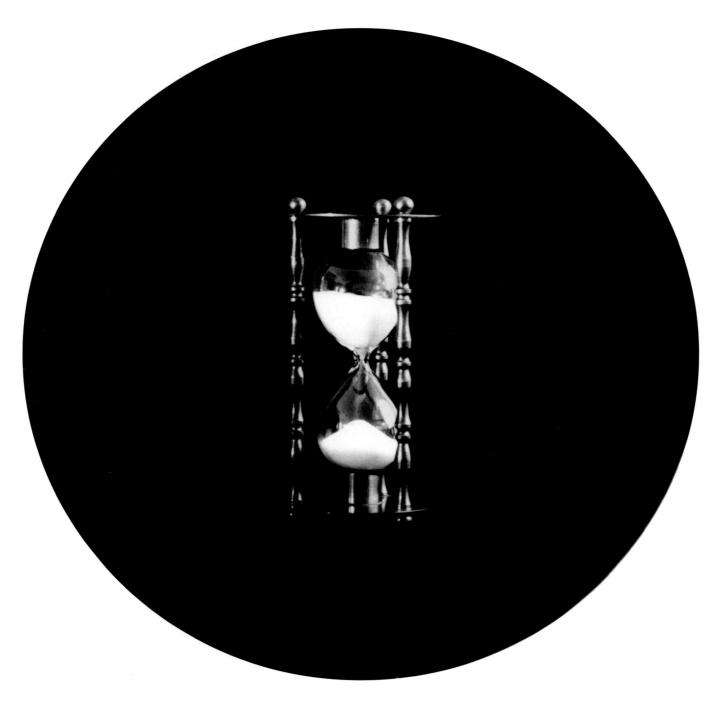

We are condemned

to kill time:

thus we die

bit by bit.

—Octavio Paz, from "Cuento de los Jardines"

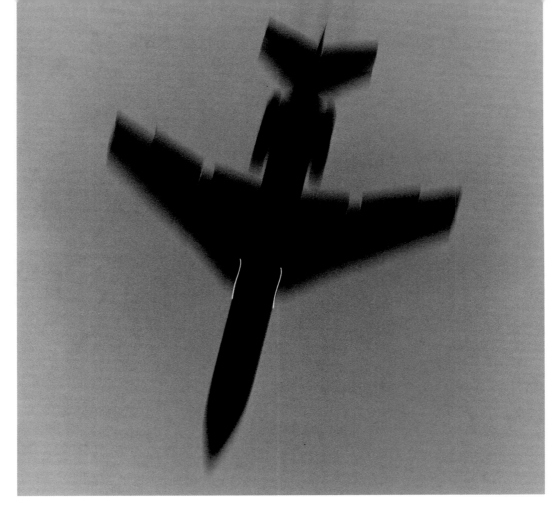

Frank Schramm, *Airbus Industries A 300B on Takeoff from Roissy Charles De Gaulle,* **1989**
Frank Schramm, *Boeing 727 on Takeoff from National Airport, Washington, D.C.,* **1992**

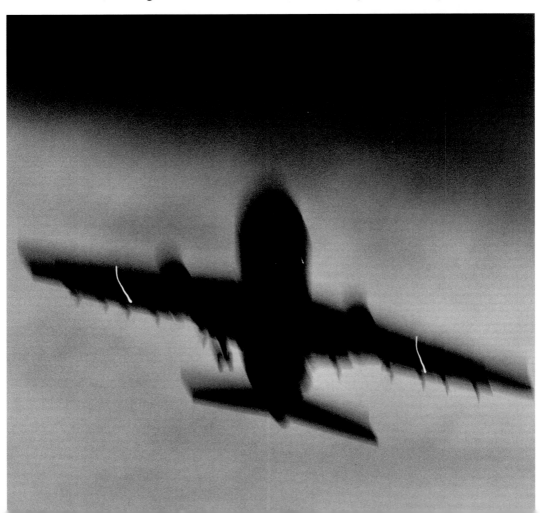

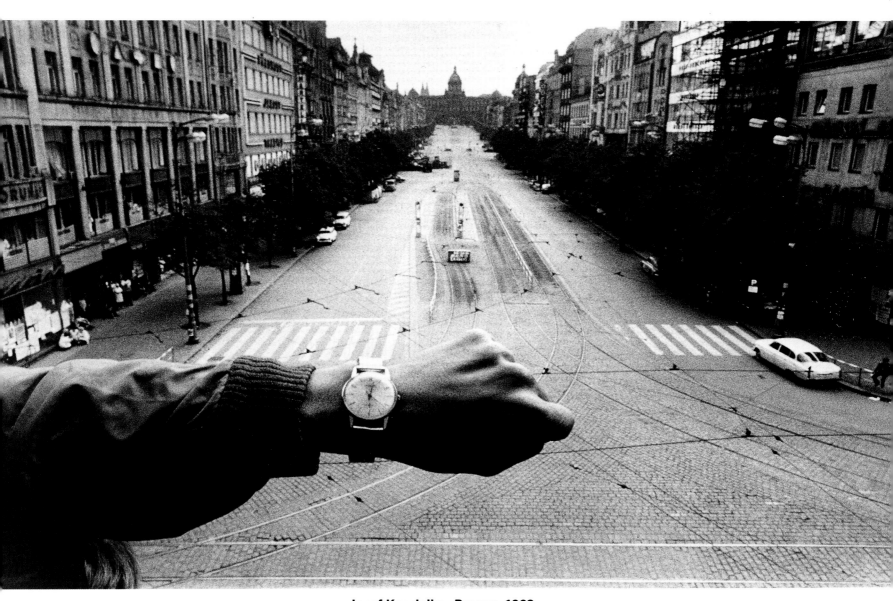

Josef Koudelka, *Prague*, 1968

... a demonstration was planned for twelve noon one day during that August.

Apparently the people were frightened of reprisals by the Russians...

the wristwatch says 12:20 and the streets are empty.

–Bill Brandt, from *Personal Choice*, 1983

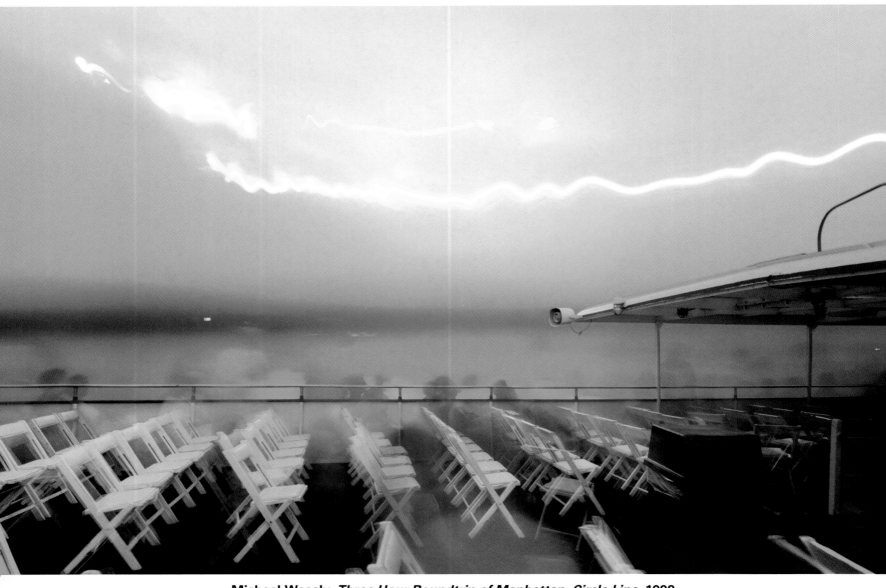

Michael Wesely, *Three Hour Roundtrip of Manhattan, Circle Line,* 1998

We were very tired, we were very merry—

we had gone back and forth all night on the ferry.

—Edna St. Vincent Millay, from "Recuerdo"

David Spero, *Interior I,* **1993**

Everything comes if a man will only wait.

—Benjamin Disraeli

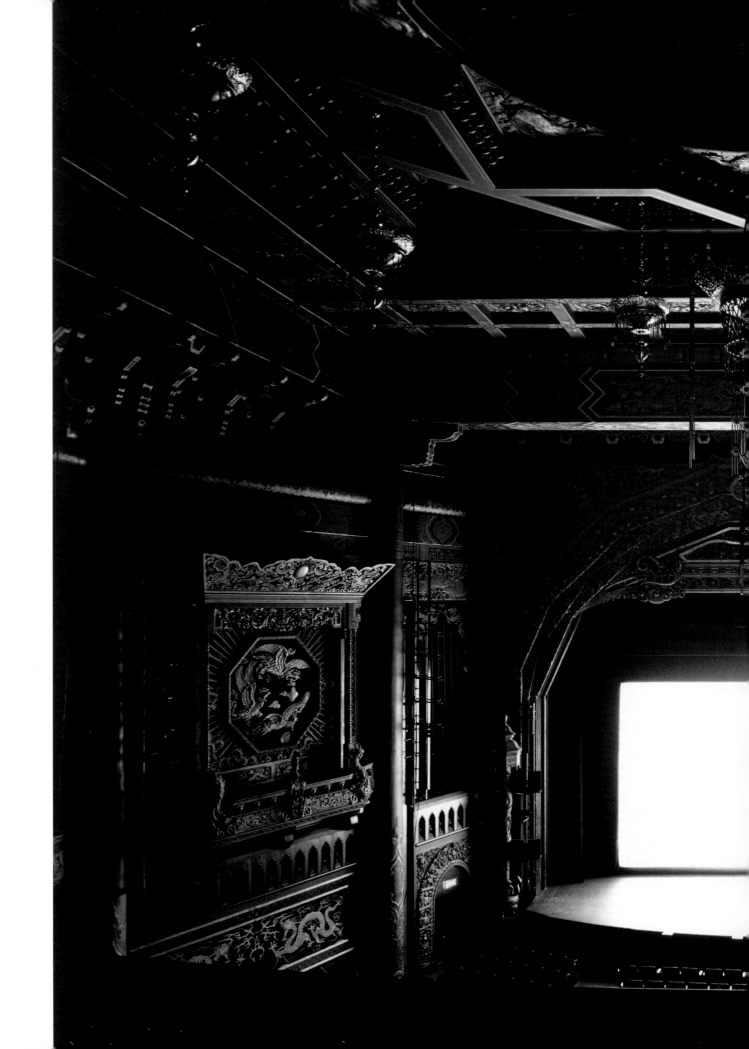

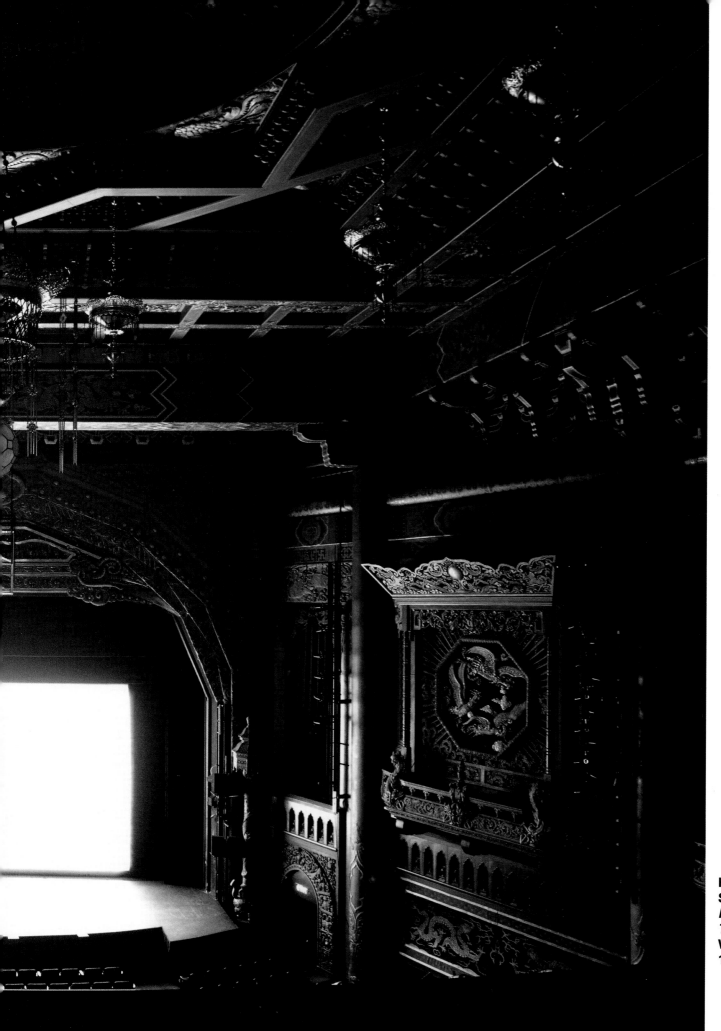

Hiroshi
Sugimoto,
*Fifth Avenue
Theater*, Seattle,
Washington,
1997

47

Light as a Recording Agent of the Past

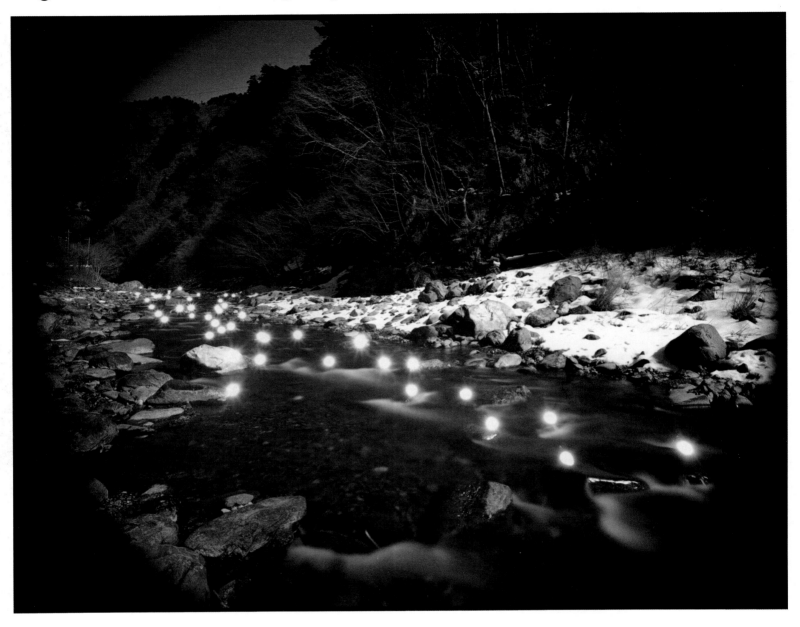

It is a wonderful thought, that every action which has ever occurred on this sunlit Earth of ours—or indeed, for that matter, anywhere within the illuminated universe—is recorded by the action of light, and is at this moment visible somewhere in space, if any eye could be there placed to receive the waves of light. Light—proceeding from the sun—falls upon objects on the earth, and is in part reflected outwards, passing through our atmosphere, and thence still onwards, we know not whither, in ever-widening waves through the ether.

The velocity with which these light-waves travel is almost inconceivable—186,000 miles per second; but if we could travel away from the Earth with a speed exceeding this, then we should clearly catch up or overtake wave after wave of light, and as we received their impact upon the retinae of our eyes, the facts which those waves record would become visible, one by one, in their proper order in chronological sequence.

Strange, indeed, would be the results of such a voyage. Old men would see themselves as they were in middle age, in youth; while withered crones might view with regret their whilom lithe and lovely forms. (continued on page 52)

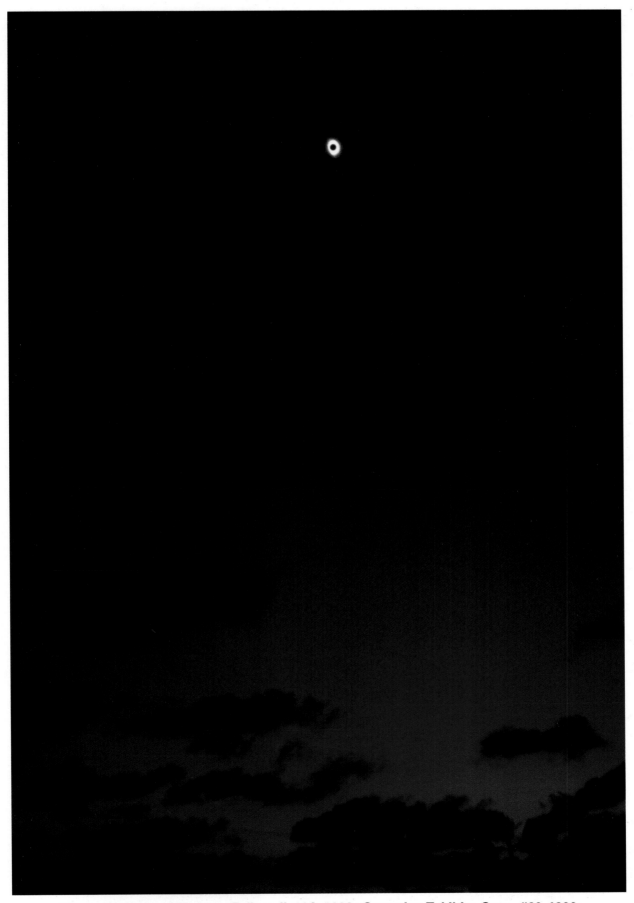

Above: Wolfgang Tillmans, *Eclipse II–18A*, 1998; *Opposite*: Tokihiro Sato, *#60*, 1990;
Page 50: Bill T. Jones, Paul Kaiser, and Shelley Eshkar, still from *Ghostcatching*, a virtual dance
installation, 1999; *Page 51*: Tokihiro Sato, *#22*, 1988

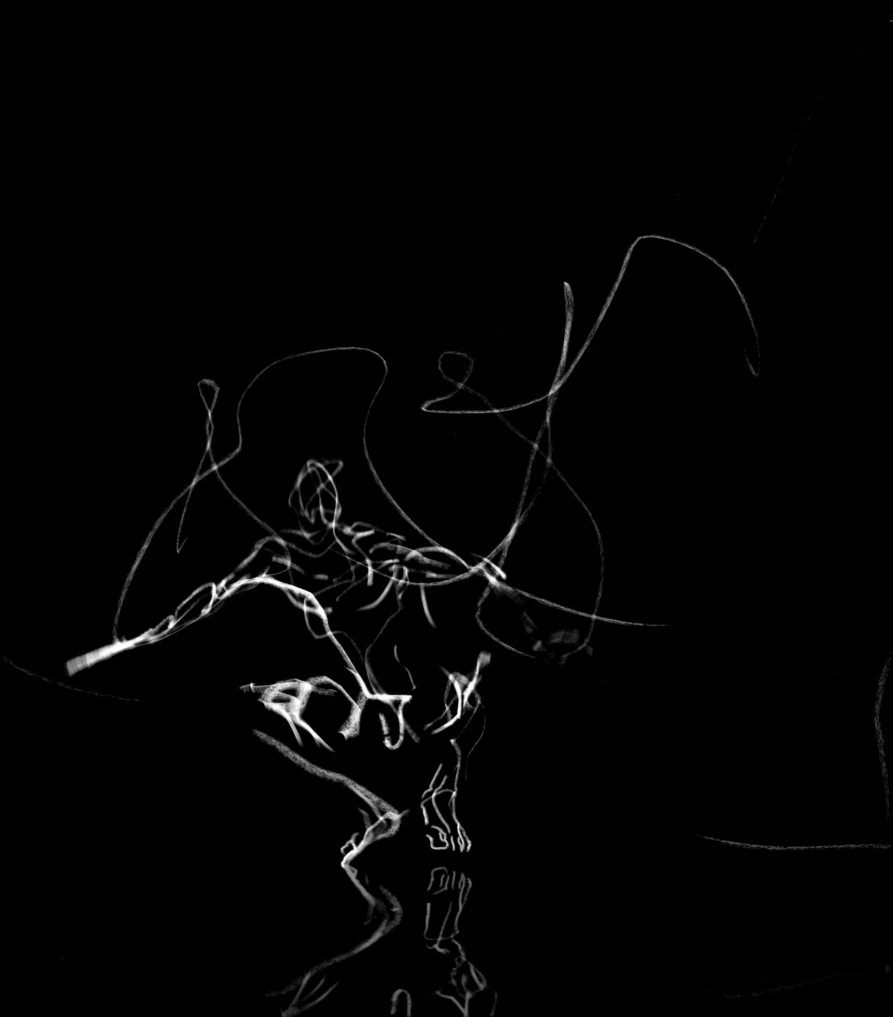

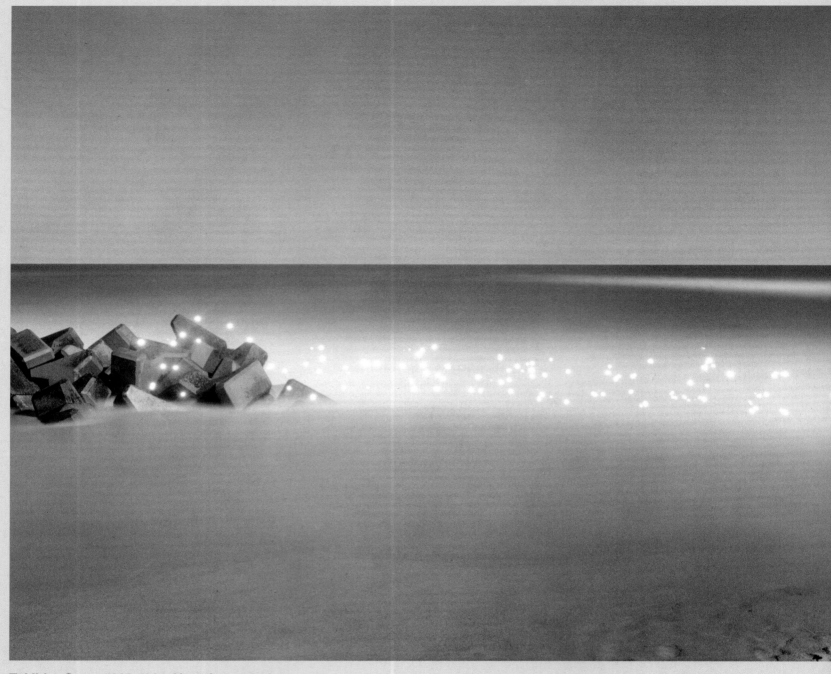

Tokihiro Sato, *#323 #324, Yotsukura*, 1996

Still speeding away from our orb, which would now be visible only as a star, we should pass in review the lives of our parents and ancestors. History would unfold itself to us. We should only have to continue the journey long enough to see Waterloo and Trafalgar fought out before our eyes; we should learn the truth as to the vaunted beauty of the Queen of Scots: and the exact landing place of Julius Caesar on the shores of Britain would no longer be a mystery.

If we had the curiosity to ascertain, by ocular demonstration, the truth of the Darwinian theory, a still more extended flight would disclose the missing links—if such existed—by which man passed from an arboreal fruit-eating ape-like creature to a reasoning omnivore.

One curious fact would be that all these events would be seen and would appear to happen backwards, or in the reverse order of their actual occurrence. We should overtake, first, the rays recording the end of any transaction, then those of the middle, and lastly, we should have revealed the cause, the

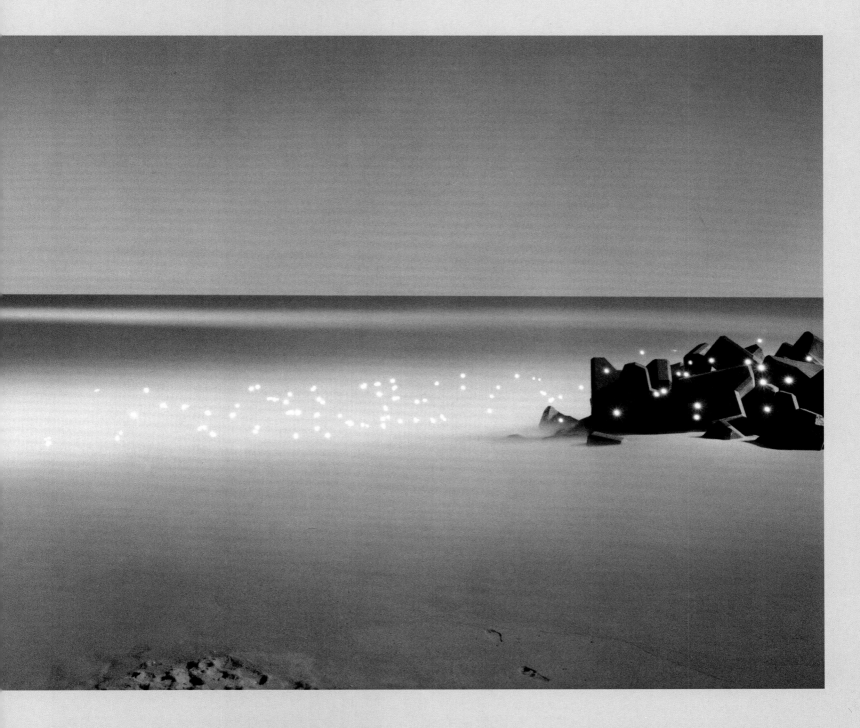

beginning of the fact. Thus, we should see Charles I's head roll on the scaffold, then the executioner's axe would fall; while lastly, the dethroned monarch would be seen to mount the scaffold. In battles we should first witness the warrior's fall, and then behold the blow that caused his overthrow. The kiss would precede the struggle for it: and the marriage would come to our knowledge before the wooing.

But, seriously, it may well be a terrible thought, that such a record of our actions undoubtedly exists.

Photographers can imagine the possibility of the presence of some exquisitely sensitive surface on the bounds of space on which such waves of light might be received, and the impression permanently retained. There would be no appeal against such a record, which would reveal, photographically, the history of our lives. The very idea should stimulate us to do nothing that will not bear developing and exhibiting to the gaze of mankind.

—W. Jerome Harrison, from *The Photographic News*, January 8, 1886

Robert Vizzini, *Tri-Cypress-Tops*, 1999

Robert Vizzini, *Untitled #31*, **1998**

We live in an old chaos of the sun

Or old dependency of day and night....

−Wallace Stevens, from "Sunday Morning"

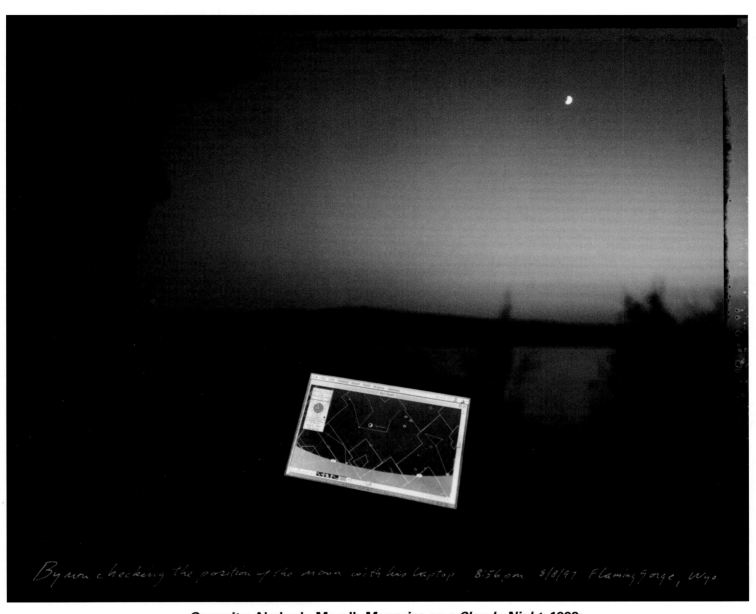

Byron checking the position of the moon with his laptop 8:56pm 5/8/97 Flaming Gorge, Wyo

***Opposite**: Abelardo Morell, **Moonrise on a Cloudy Night**, 1993;*
***Above**: Mark Klett, **Byron Checking the Position of the Moon with His Laptop**, 1997*

Breathless

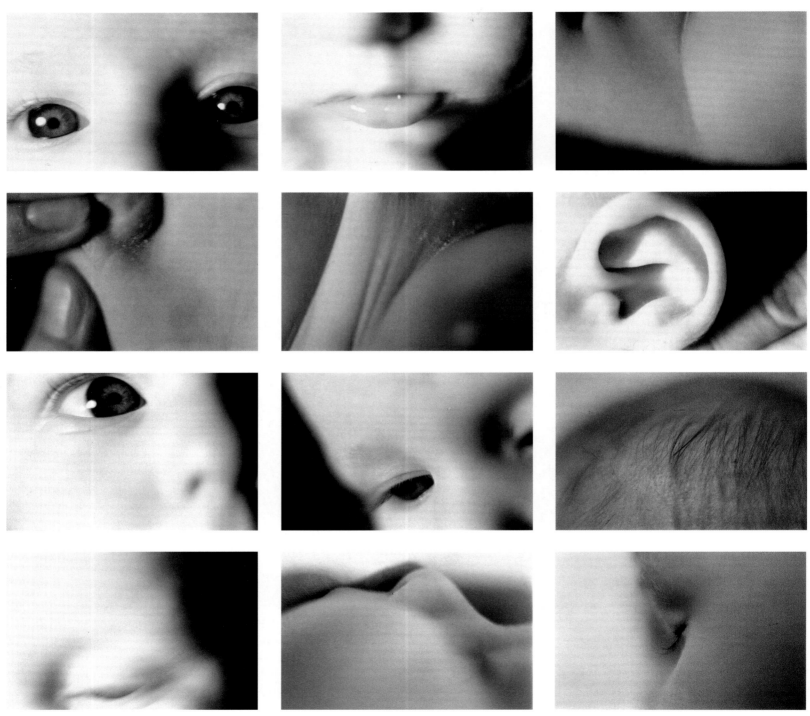

Above: Mary Kelly, *Primapara*, from the "Bathing Series," 1974;
Opposite: Rineke Dijkstra, *Tecla*, Amsterdam, The Netherlands, May 16, 1999

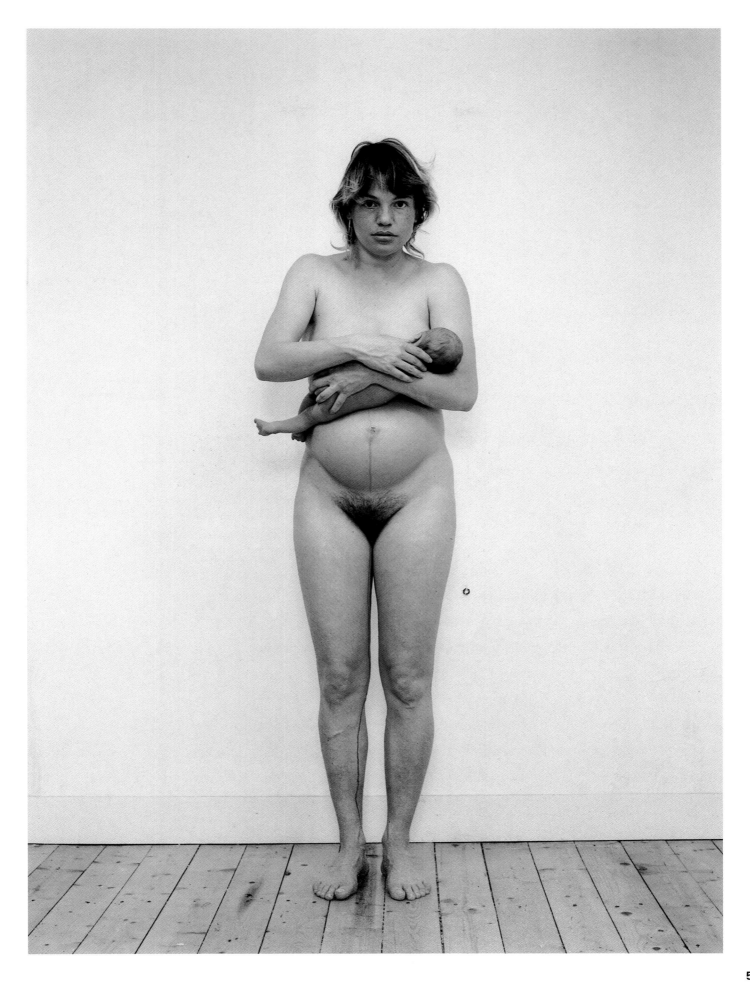

Above: Heather Ackroyd and Daniel Harvey, *Snake in the Grass*, 1998
Opposite: Heather Ackroyd and Daniel Harvey, *Mother and Child*, 1998

The concept that photography was a means for nature to leave her own imprint through the action of sunlight accounted for much of the magical allure of the medium at its inception. The photogenic drawings, or photograms, of plants produced by Talbot from the 1830s aligned conceptually with the phrases that he wrote in his scientific notebooks: "Nature magnified by Herself" or "Look through Nature to Nature's God." These were musings that explored the notion of a universal divine order through nature. Heather Ackroyd and Daniel Harvey have resurrected some of this natural magic over recent years not through the use of paper and chemicals but by returning, literally, to the roots of photographic image making.

Their unique images are made from grass grown from seed—one of nature's most abundant raw materials—that records as it grows the shadings of a projected negative. The subtle yellows, greens, and tonal variations are entirely produced by the pigment chlorophyll that gives life to plants via the natural action of photosynthesis.

Pictures such as these flicker with life while their transient nature makes us acutely aware of passing time. In *Middlemarch*, her finely wrought examination of the structures of human life, George Elliot wrote: "If we had a keen vision and feeling of all ordinary human life, it would be like hearing the grass grow and the squirrel's heart beat." Ackroyd and Harvey's pictures create substance from this vision in tapestries, intricately woven from blades of grass, that embody a natural order and hint at the carefully balanced laws of the cycle of life.

—Martin Barnes

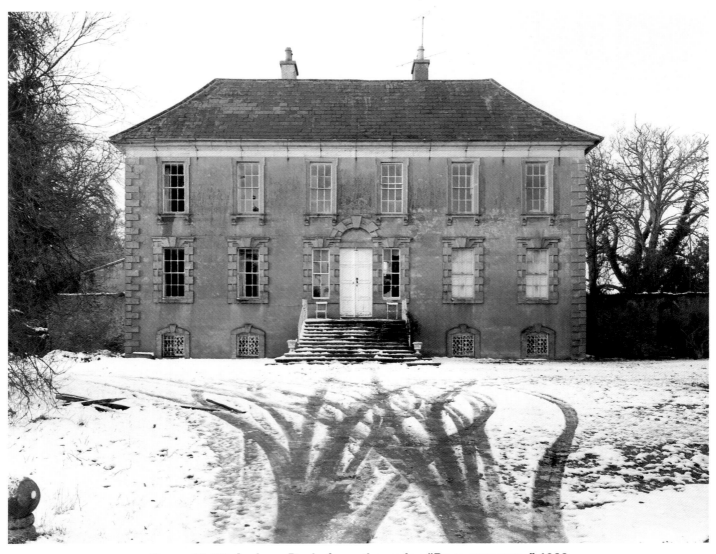

Pages 62–63: Andrew Bush, from the series "Bonnettstown," 1982

As inevitably as weathering,
the process of inhabiting a space leaves
the marks of time all over it, and so
constitutes a declension from the
architect's ideal. A house that welcomes
our stuff, our furniture and pictures,
our keepsakes…is one that we have been
invited in some measure to help create or
finish; ultimately such a house will tell a
story about us, individuals with a history.

—Michael Pollan, from *A Place of My Own*

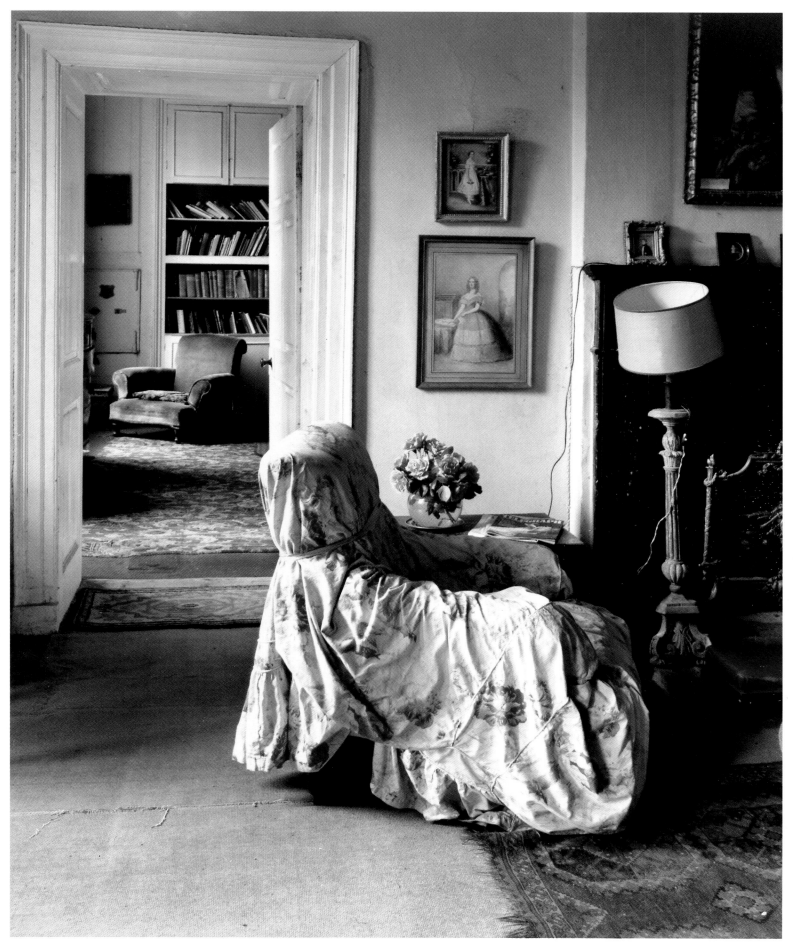

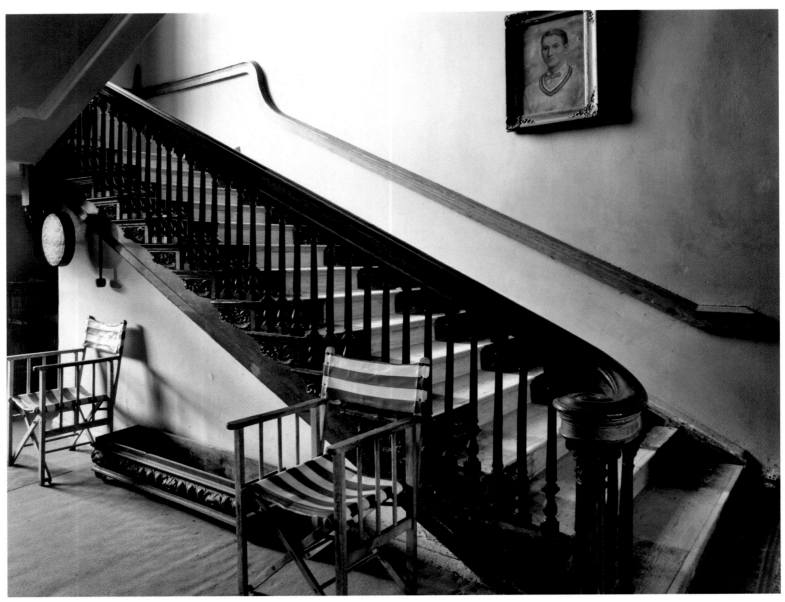

Andrew Bush, from the series "Bonnettstown," 1982

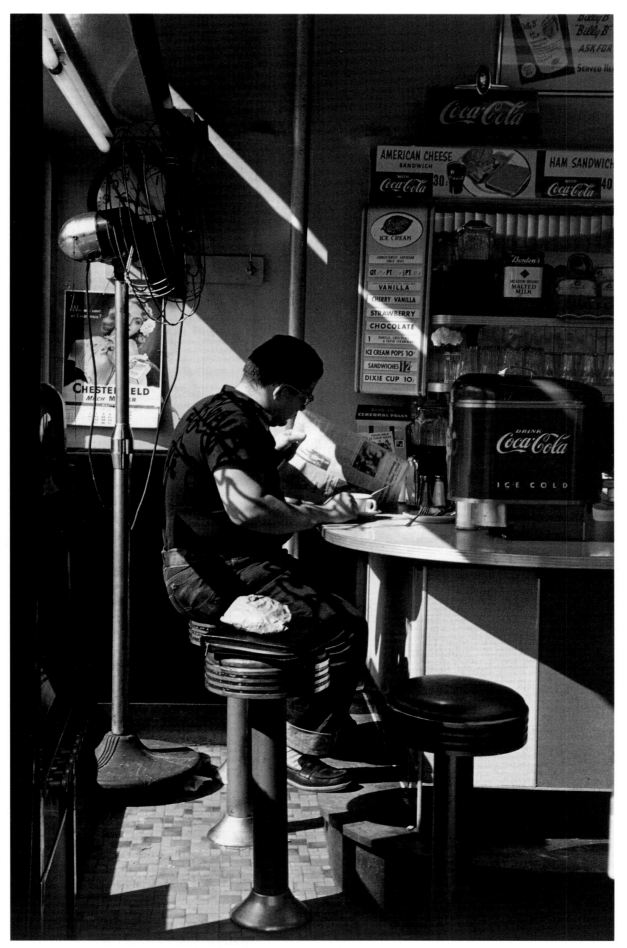

Louis Stettner, *Diner*, New York, 1952

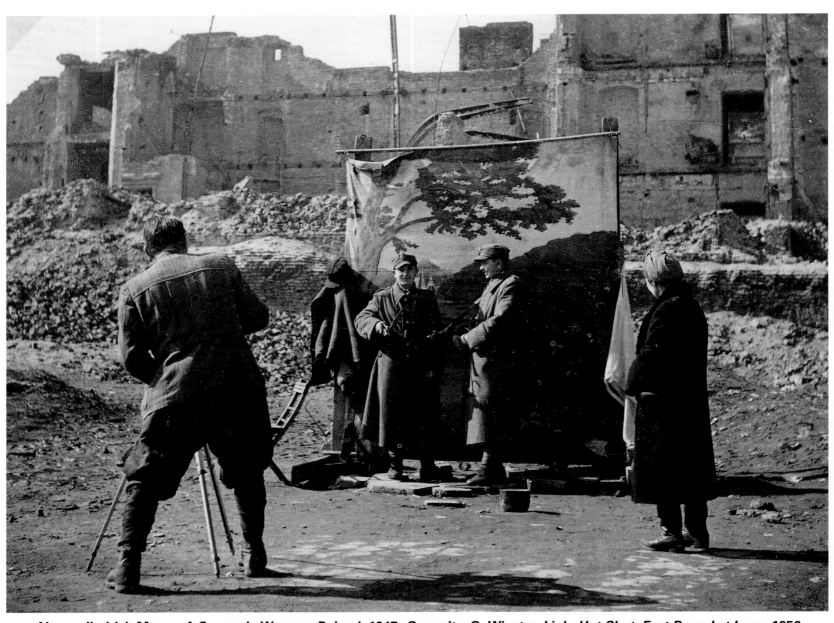

Above: Jindrich Marco, *A Souvenir*, Warsaw, Poland, 1947; *Opposite*: O. Winston Link, *Hot Shot, East Bound at Iager*, 1956

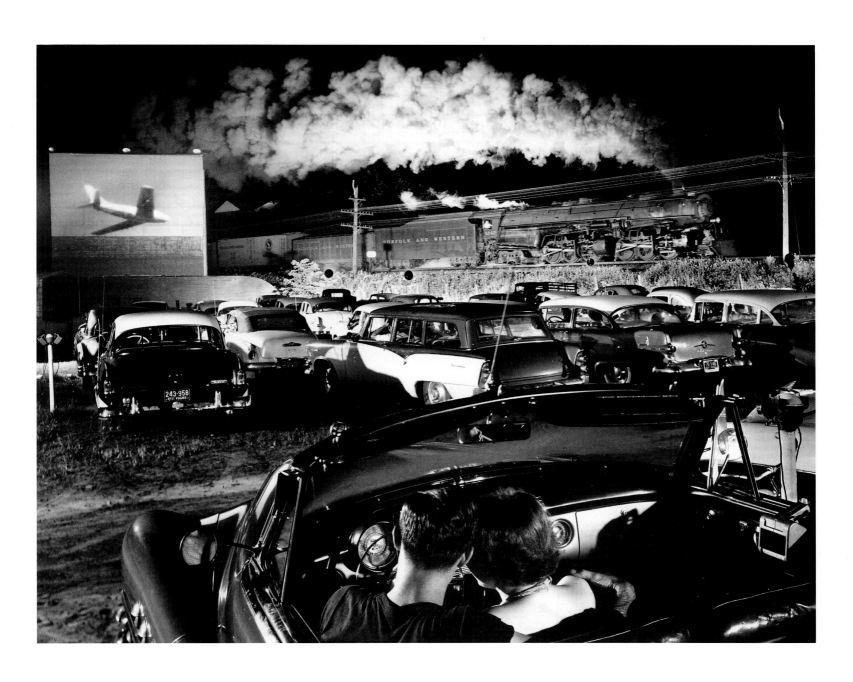

No one has lived in the past and no one will live in the future.

The present is the form of all life, and there are no means by which this can be avoided.

—Jean-Luc Godard, from *Alphaville*

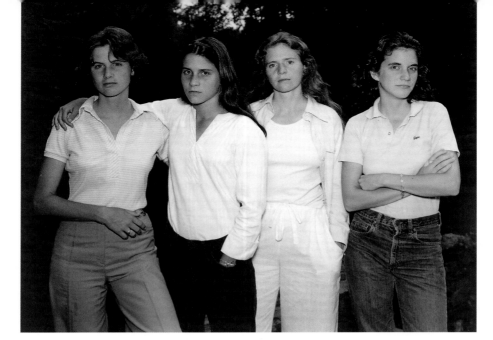

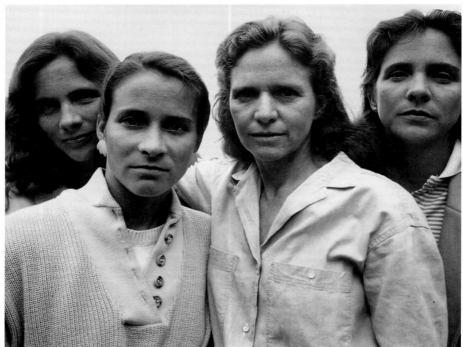

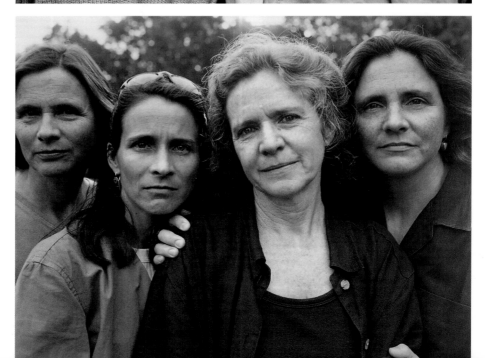

Nicholas Nixon,
The Brown Sisters,
Top: 1975
Middle: 1987
Bottom: 1999

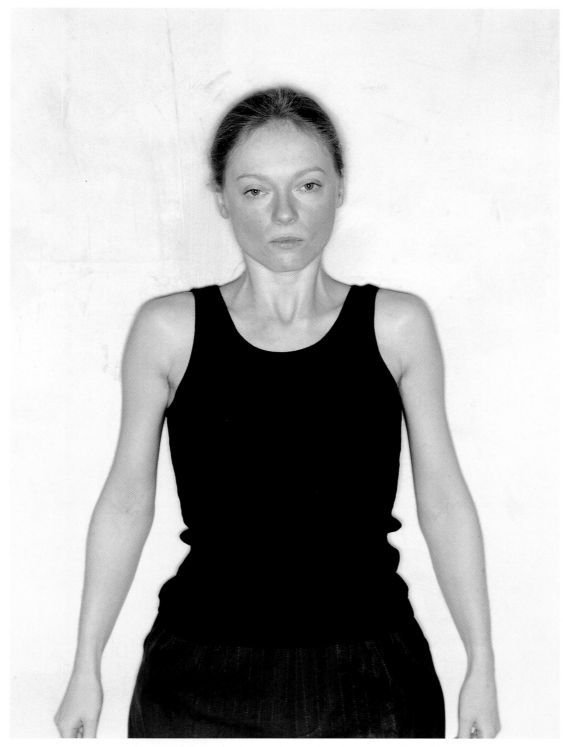

Bettina Von Zwehl, from the series "Untitled III," 1999

The millennium is in many ways an artificial event, and yet it has had many real consequences—causing the creation of new architectural, historical, and even political monuments. Like our predecessors one thousand years ago, we have—in spite of ourselves—approached the millennium with bated breath. The terror of Apocalypse 1000 was reprised by the stress of Y2K. Stress had become a keyword of our fin de siècle. This is the subject of a series of photographs made by Bettina von Zwehl. Her sitters (actually carefully aranged in horizontal positions) have held their breath for ninety seconds, making us ponder breath as the stuff of life, of poetic and musical measure, and as the opposite of that other measure—death. —M H-B

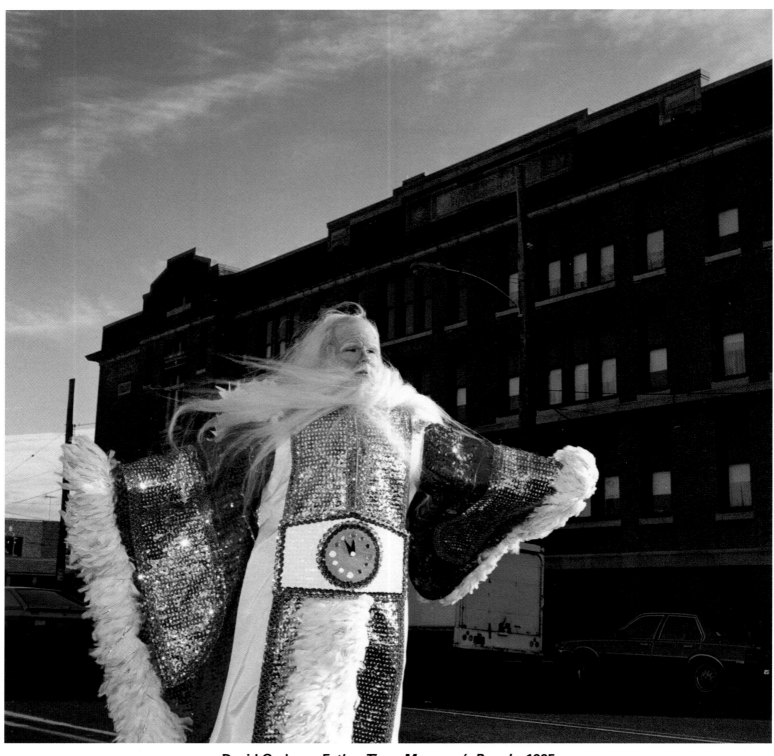

David Graham, *Father Time, Mummer's Parade,* 1995

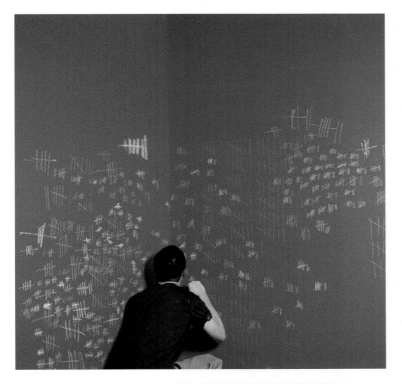 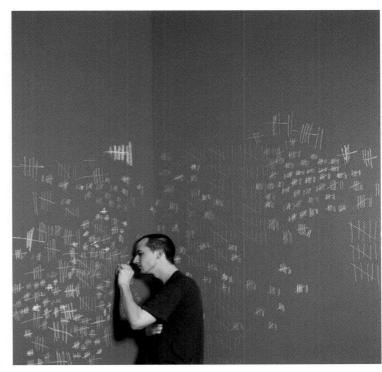

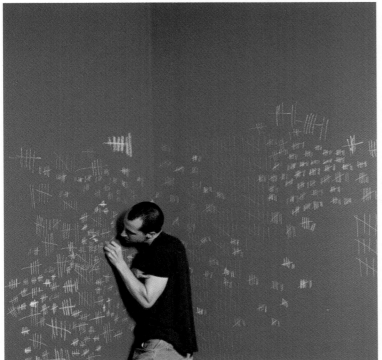

Amy Berkley, *Waiting,* **1999**

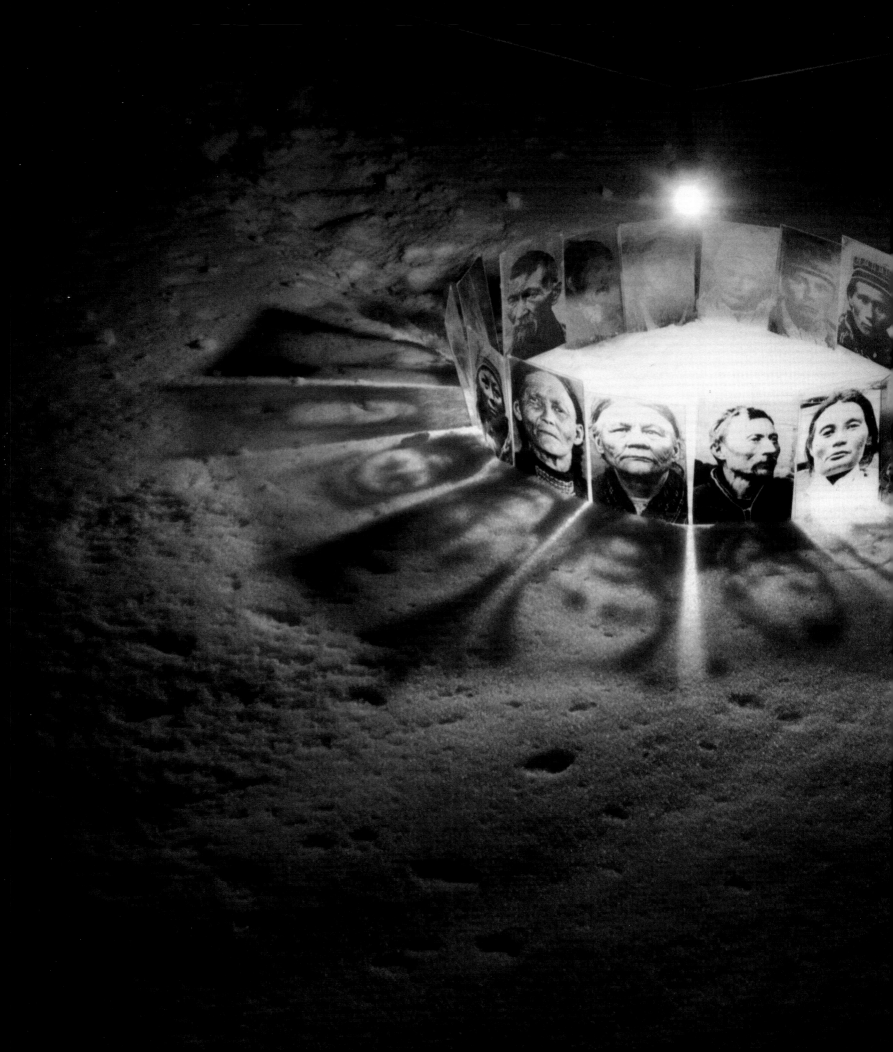

One must always maintain one's connection to the past and yet ceaselessly pull away from it. To remain in touch with the past requires a love of memory. To remain in touch with the past requires a constant imaginative effort.

—Gaston Bachelard, from *Fragments of a Poetics of Fire*

Jorma Puranen, from the series "Imaginary Homecoming," 1992

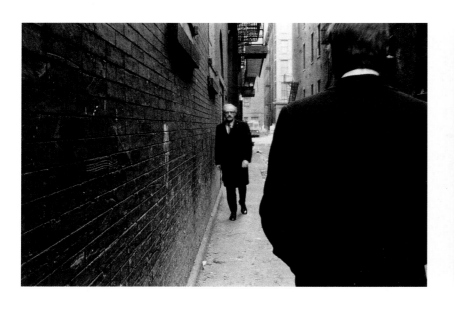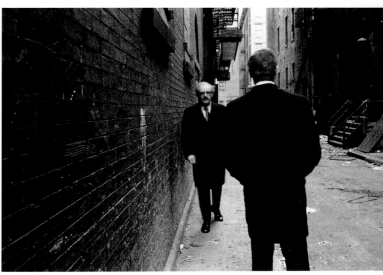

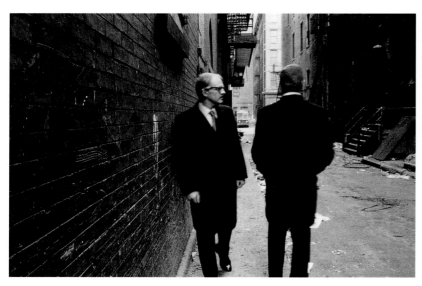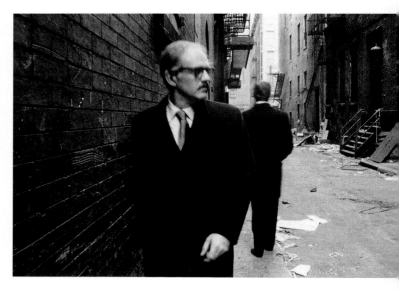

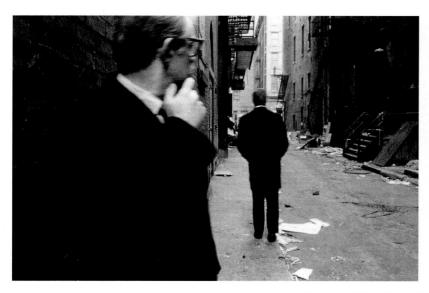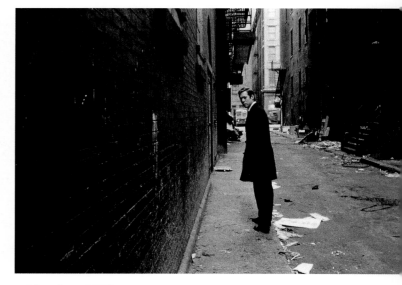

Duane Michals, *Chance Meeting*, 1972

Bill Jacobson, *Interim Portrait #373,* **1992**

PEOPLE AND IDEAS

Bruce Bernard, *Century*.
London: Phaidon Press, 1999, 1120 pages.
Reviewed by Mark Haworth-Booth

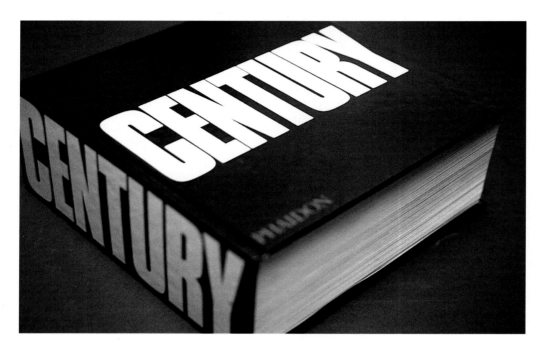

Not long ago the BBC aired a drama serial by Stephen Poliakoff called *Shooting the Past,* which was subsequently aired on PBS in the United States. It was a gripping, if over-the-top, study of an old photo library that suddenly finds itself at the mercy of American business studies experts. The library was based on the BBC's own Hulton picture library, which is now the Hulton-Getty. The series championed the value and eloquence of photographic records but also—in a bravura performance by Timothy Spall—the strangely talented people who can be found looking after, or into, them. Such people, picture editors and researchers, sometimes possess a startlingly accurate "photographic memory" and an intuitive divining-rod that leads them through vast archives to the images they need. Bruce Bernard is one of these. At the back of this wonderbook is his portrait by Lucian Freud. He stands there, a familiar

mensch in open-necked shirt and unbuttoned jacket who has remained in his forties for the twenty-five years I've known him. He fell into the trade in 1967, he says, "when I was as good as down and out." The designer Germano Facetti offered him a job doing picture research for a partwork he had designed called *History of the Twentieth Century.* I remember seeking it out on newsstands, and I recall Bernard's stints as picture editor at *The Sunday Times Magazine* and later the *Independent Magazine*—both, as it turned out, in those magazines' better days. He is much more than a magazine man, of course, and his book *Photodiscovery* (1980) embodied a new excitement about the language of photography that made it seem like a completely new art form. More recently he curated *All Human Life,* a vast, fascinating exhibition from the Hulton hoard, shown at the Barbican Art Gallery in 1996. I don't know

anyone else with either the *chutzpah* or the qualifications to attempt a book like this.

Century is extraordinary. There is a series of fat photographic books published by Taschen in Cologne called "brick-books"—but Bernard and his publishers have, so to speak, turned the photographic brick into something approaching marble. *Century* weighs twelve pounds, contains a thousand photographs, and comes in its own little suitcase with a handle. Despite its bulk, the book sits obediently in the lap, opens properly, and is a pleasure to use. The price is startlingly modest for such a lavish production. Each photograph has a one-line caption, some of them very entertaining. An example from 1923 introduces us to "The Dolly Sisters—cabaret artists and playgirls—one of whom, Jenny, excelled at spending other people's fortunes and being forgiven." Text sections occur at intervals throughout the book. Here we find more extended captions, plus introductions to each period, by the Canadian historian Terence McNamee. These sections also feature spreads of quotations assembled from the relevant decades by Richard Davenport-Hines. My favorite is this Reaganesque profundity from Woody Allen ("My Speech to the Graduates"): "More than any other time in history, mankind faces a crossroads. One path leads to despair and utter hopelessness. The other to total extinction. Let us pray we have the wisdom to choose correctly."

So, has Bernard chosen correctly? His introduction rehearses some dilemmas: he worries that "star" pictures are devalued by overuse, that perhaps he has included too much war and horror, or succumbed against his will to the imagery of Hitler and his gang. He alerts us to the dynamics between two pictures in a page spread, which designers used to call "the

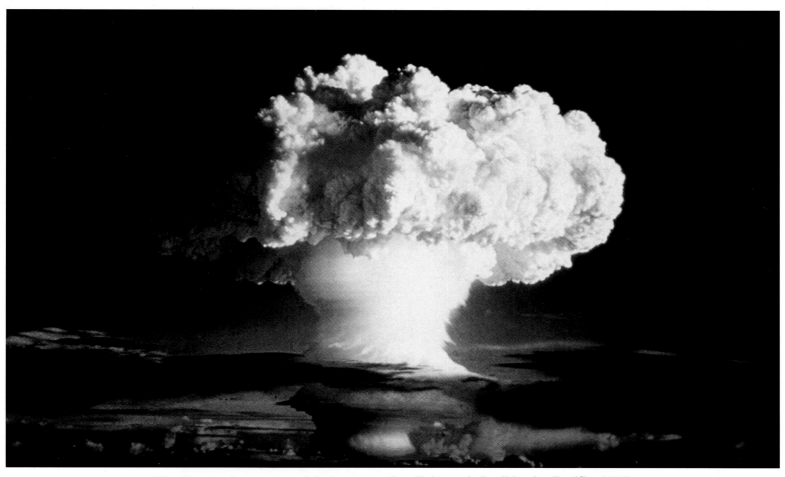

The first hydrogen bomb being tested at Eniwetok Atoll in the Pacific, 1952

third effect." Such pairings can release new meanings in pictures—or be fatally compromising. My favorite pairing occurs early on, in 1903. On the left Orville Wright's kite-like plane achieves powered-flight at Kitty Hawk, North Carolina. Bernard adds that "The achievement would radically change life and death on earth." A man on the facing page fires a gun straight at the reader from close-range. It is a still from *The Great Train Robbery*—"almost certainly the first blank cartridge fired at a movie audience." The pairing redeems the "iconic" Kitty Hawk picture and ignites ideas about flight and film as the defining technologies of our century, and further reflections on universalism and violence. The book gathers narrative momentum, averaging ten images for each year. Most are hard history, some involv-

ing a long-forgotten cast—although we come across forgotten personages who seem wildly contemporary. Clarence Darrow and William Jennings Bryan fought a great court room duel over John T. Scopes in Tennessee in 1925. Scopes had dared to teach children about Darwin. This picture must have been chosen well before the current antics over teaching evolution in the state of Kansas. Some readers will no doubt readily recall the infamous treatment of the "Scottsboro Boys" (1935), but this one was grateful for their picture and detailed information about their fate. Indeed, the volume is packed with victims, and many sequences are bleak. Some will begrudge the presence of so many photogenically uniformed Nazis and Fascists—and the absence of such political leaders as, say, Ataturk and Attlee. Hard history may make some read-

ers yearn for more social life—for pictures about, say, fast-food, supermarkets, computers. Readers will inevitably find particular events either missing (like the discovery of the structure of DNA) or represented from an unusual angle (the Tiananmen Square Massacre). It is a pleasure to argue with this book. The compiler is both a great showman and a serious chronicler. He retains one's attention and faith right the way through. The mix of pictures is judiciously enhanced by images that convey experience without news. The very first photograph, by Eugene Atget, shows us a decrepit and possibly blind Parisian organ-grinder, whose female associate lifts her confident young face to the morning light —as if the old century is turning into the new before our very eyes. And the last picture? You'll be surprised.

Mariko Mori, *Empty Dream*
Brooklyn Museum of Art: April 8–August 15, 1999
By Lesley A. Martin

Enter the Empty Dream and welcome to the future—the future of art, a future populated by art-stars of the moment, a future that is absolutely now. Or you may find yourself at Mariko Mori's first major solo exhibition, a show that opened at the Serpentine Gallery in London, traveled next to Chicago's Museum of Centemporary Art and finally to the Brooklyn Museum of Art (BMA) this past April. Greeting visitors at the door to the BMA installation was one of Japanese-born Mori's personas, a shimmering image of the artist as a future techno-pop star (*Birth of a Star*, 1995). Exaggerated to mythic proportions, she comes —fully posable!—teetering on tiptoes, twisted in an awkward knock-kneed stance. Bubble-like spheres in primary, plastic colors orbit around her. She is decked out with oversized headphones, a matching space-age microphone, and her own soundtrack. The saccharin-sweet song, a lilting repetition of the name of a popular Japanese television show, infiltrates itself into the viewer's consciousness as it loops, inanely. The figure is almost 3-D, just on the verge of holographic; an effect achieved by the use of layers of Duratran over a radiant lightbox.

Mori's beguiling pop idol sensibility works a contradictory spell on the viewer. Simultaneously vapid and portentous, she culls a range of ver-

nacular fantasies and identities for herself from various corners of contemporary kitsch culture. Spinning them into bewitching, occasionally bewildering characters, her work combines the media-saviness of Cindy Sherman's film stills and the crafted-persona of Icelandic singer, Björk; the MTV-aesthetic resonant in Swiss videographer Pipilotti Rist's work and Japanese cartoon-character cuteness (think Pokémon, Hello Kitty, Sailor Moon).

Born in Tokyo in 1967, educated at Bunka

Fashion College, London's Chelsea College of Art, and the Whitney Museum's Independent Study Program in New York, Mori has been touted as a credit to British, American, and Japanese art scenes. And while there is no doubt that Mori is a flavor of the moment, there is plenty of evidence to suggest that she may be more. *Empty Dream* traces a crucial progression of this young artist's work from a vaguely ambivalent critique of media-saturated identity to a full embrace of the media-information compost from which future mythologies will emerge.

At the Brooklyn Museum of Art, the exhibition was cool, sparse, presenting a total of fourteen large-size photo and video pieces in all, including one "enlightenment capsule," a sculptural work that uses a fiber-optic solar energy system developed by Mori's father. Ample white space surrounded each one; the curvaceous, milky walls that isolated the video piece *Miko no Inori* (1996) were more reminiscent of the interior of a sleek contemporary boutique than of a typical museum space—not an inappropriate setting for an artist who started out as a fashion model. The slickness and scale of the majority of the still images—seven- and nine-foot-tall

Mariko Mori,
***Birth of a Star*, 1995**

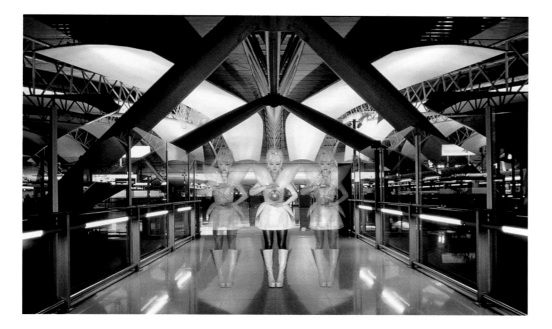

Cibachrome panels mounted flush on aluminum or pewter frames, ten-by-twenty-foot-wide color photographs printed on glass —contributed to the billboard-style presence of Mori's work.

In the first segment of the exhibition, featuring images from her series "Made In Japan," Mori mines the familiar territory of identity as cultivated surface. Using herself as a model, posed as a variety of fantastic cyborg characters in slick sci-fi settings (the sets seem constructed but are in fact contemporary Japan), she conflates the artificial and the real, mimicking the process of creating a contemporary "self" out of today's information/image-stream. Mori has called her work social commentary and refers to her cool neo-human nymphets as analytical of the role of women in Japan. Yet in this series, the viewer does not sense the Orwellian fear of a synthesized future that one might expect. Ultimately, Mori's images hint at a criticism of the synthetic reality created by technology and media, but the seamlessness of her approach disarms the viewer. In *Tea Ceremony III* (1995), as a vulcan-eared office lady,

Mori smilingly offers traditional green tea to passersby on a street in Tokyo; in *Come Play With Me* (1994), she becomes a blue-haired inhabitant of the far-off lands of Sega or Nintendo, beckoning us to enter her world, or for us to release her into ours; in the eponymous *Empty Dream* (1995), a trio of mermaid-Moris frolic in an indoor wave pool, where the horizon betrays an urban skyline just visible through a gauze-like "sky."

A product of the glut of images and visual stimuli that overwhelm us today, Mori may prompt questions about her sources of inspiration, but ultimately takes no steps away from them. Even when drawing on older Eastern cultural and philosophical elements, the governing aesthetic in Mori's work offers us traditional visual motifs from Japanese mythology via a contemporary Jap-pop aesthetic.

The trajectory of Mori's work shifts in this direction at the mid-point of the exhibition with *The Last Departure* (1996) and her video *Miko no Inori.* Both are set in the *Blade Runner* chrome and steel of Renzo Piano's Kansai International Airport. In the five-panel video,

Mori repetitively performs a ritualistic incantation, caressing and offering up a crystal ball-like orb to the viewer. In *The Last Departure,* dressed in pearlescent space-angel gear, Mori stands shimmering, translucent, and in triplicate. She clasps the same orb as the shaman girl in the video, ready to catapult us into a utopian future, into the esoteric landscape that Mori creates in the video piece *Kumano* (1997–98) and the accompanying stills that follow.

From cyborg cuties to alien angels may seem only a slight redirection, but the techno-shamanistic visions of the second half of *Empty Dream* launch Mori into new territory. By drawing on older, traditional Eastern cultural and philosophical elements, she seems to be striving to transcend the concerns of late-twentieth-century role-playing to fill the emptiness of her prior constructed selves. The catalog that accompanies the show (an indispensible aid to interpreting some of the references encoded in the work), quotes Mori earnestly stating her belief in "a future civilization of higher dimensions, with the boundary between mind and matter transcended," a future in which science and religion—not to mention personal identity—find unification and resolution via art and image.

In the exhibition's final series of color photographs from series "Esoteric Cosmos" and the video *Kumano* (which was completed the day before the opening of the BMA show and did not appear in London or Chicago), Mori continues to explore a variety of personas drawn from Japanese culture. In these two pieces, however, the source of her imagery comes less directly from the television than it does from traditional Japanese mythology, in

particular the mythology of Amida Buddhism. Amida Buddhism places an emphasis on magic, ritual, and ceremony; the visual image is considered a powerful tool of enlightenment and transcendence. And although the cartoon-ethos is certainly still present in this work, Mori moves away from *Barbarella*-like space vixens. Her focus is instead on a futurism that grounds itself in tradition and spirituality. Her new personas leave the future-metropolis behind and instead inhabit dense forests, undulating sand dunes and deserts, stalactite-rich caves, or the fantastically empty realm of a pink-hued paradise.

The 3-D installation *Nirvana* (1996–97), and the color photographic still *Pure Land* (1996–98), most solidly unify the progression of Mori's concerns. In the BMA exhibition, the video was presented at the beginning of the exhibition, to the right of the entrance, and the still image at the end, creating a mobius-like progression through Mori's work, ending and beginning with the same incarnation of a transcendantly divine

Mori. It's not difficult to imagine the disco star of her earlier piece in *Birth of a Star* reincarnated as this rave-kid boddhisattva. The three-dimensional graphic effects of *Nirvana* are impressive, tantalizing, particularly when Mori, in a costume based on classic Buddhist iconography, floats gently toward the audience, scattering lotus petals. The petals appear to rain down toward the floor, directly into the viewers' 3D glasses. Hovering in *Pure Land* (also known as the Western Paradise of Amida Buddhism), Mori is encircled by candy-colored, computer-generated handmaids who accompany her chant with tweedling pipes and stringed instruments. The repetitive chant has changed from the banal incantation of a television theme song of the earlier piece into a spiritual invocation: "Kamitachi ni aitiai." (I want to meet the divine beings/god). Floating effortlessly above a lotus (an ancient symbol of awakening and of enlightenment), Mori cradles another crystalline droplet-shaped orb. As the video progresses, she

sends it toward the viewer, so that it shimmers in suspension, jewel-like, an offering of radiating energy and light.

It is in pieces like *Nirvana* that Mariko Mori, who starts out simply as adorable, uses the superficial glaze of cartoon-inspired cuteness to draw us into spaces where spiritualism, traditional Japanese mythology, popular forms of imaging the self through fantasy, fashion, and other technologies blend. In the first phase of her work, Mori's images are invitations to a seductive fantasy of a cool, cyborg-populated future, where a star is not so much born as constructed. In the second phase of Mori's nascent cosmology, we become potential stars and may each be reborn as divine beings of our own creation. Mori's work reflects a shift in the collective popular imagination, which forages omnivorously for images to lift and recycle. As is evident in *Empty Dream*, it is precisely from such a media mulch that new meanings, new mythologies will arise.

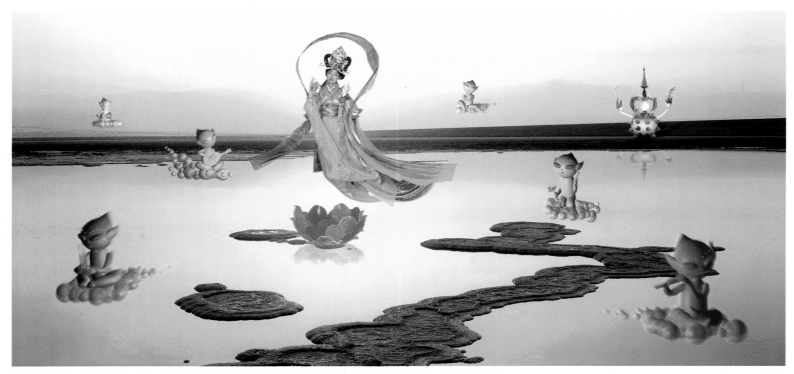

Mariko Mori, *Pure Land,* 1996–98

HONORARY PUBLISHER
Robert Anthoine
AT&T
Cornell Capa
Honorary Raymond C.
 Clevenger III
Mr. & Mrs. Ronald E. Compton
Geraldine R. Dodge
 Foundation
Fairweather Foundation
Ford Motor Company
Annette & Jack Friedland
Furthermore, The Publication
 Program of the J. M.
 Kaplan Fund
Barry H. Garfinkel
Gere Foundation
Sondra Gilman & Celso
 Gonzalez-Falla
John Gutfreund
Fred Harris
Lynne & Harold Honickman
House of Blues, Inc.
Michael Balfe Howard
Jerome Foundation
Eastman Kodak Company
Elizabeth & Mark Levine
Barnabas McHenry
Ambrose Monell Foundation
The Kenneth A. Scott
 Charitable Trust,
 A KeyBank Trust
Joseph & Constance Smukler
Martha & Edward Snider
Janice B. Stanton
The Starr Foundation
Marion Boulton Stroud
Willard B. Taylor
Jane Smith Turner Foundation
Rhett Turner
The Turner Foundation
Robert Yellowlees
Tommaso Zanzotto

BENEFACTOR
E. Alkazi
Banana Republic
The Buhl Foundation,
 New York
Antonia Paepcke DuBrul
James P. Garland
Hironao Ishii
Jephson Educational Trusts,
 The Chase Manhattan
 Private Bank
Jennifer Johnson
Lord Palumbo
Perlman Family Foundation
The Pfundt Foundation
Jonathan Rose
Shelley and Donald Rubin
 Foundation

PATRON
Eric L. Almquist
James F. Dorethy
Philip Howard
Patrick McMullan

DONOR
Diane L. Ackerman
Countess of Airlie
Steven Ames
Harriett Ames Charitable
 Trust

Milton & Sally Avery Arts
 Foundation
Martha Robson Bardach
Wayne G. Basler
Jessica Brackman
Christopher Brookhouse
Henry M. Buhl
Jonathan Bulkeley
Consulate General of Spain
Continental Airlines
Thomas S. Cottrell
Paula & Mark Craig
Michael Dubiner
Niko Elmaleh
William Enos
Mr. & Mrs. John French
Betsy & Jim Froyd
Mark Gordon
Heal-Cotsifas Foto
Dean & Felice Holt
Eikoh Hosoe
Julie A. Jensen
Morris & Sophie Kardon
 Foundation
Hiroyuki Kariya
Michael Keith
Graham J. Kelly
Regina Kelly
Mildred Kennedy
Ken King
Wayne C. Kodey
William D. Kornreich
Chick & Cheryl Kozloff
Deborah Kuschner
Levin Management Co., Inc.
Alan E. Manley
Richard L. Menschel
Stephen Myers
Ted Nierenberg
David N. Pincus
Karen M. Pritzker
Joan Puckett
Elizabeth K. Raymond
Yvetta Rechler-Newman
William Windsor Richardson
Elizabeth Barlow Rogers
Michael Schiffer
Ken Souser
Arthur Steinman
Rodney & Gail Susholtz
Daniel T. Teitelbaum
Artur Walther
Hubert de Wangen
Elise I. Weisbach
Claire Yaffa

FRIEND
Frank Arisman
John Bolebruch
Eleanor Briggs
Josephine Bush
Dana & Neil Cohen
Bruce Van Dusen
Ronald Eichhorn
Howard Greenberg Gallery
Nicholas J. Gutfreund
Jeanne & Stephen Haeckel
Aubrey W. Haines
International Center of
 Photography
Walter J. Henning
The William Talbot Hillman
 Foundation
Sandpiper Fund, Inc.
James Miller

Frank N. Norris
Richard Rabinowitz
John P. Rask
Ira M. Resnick Foundation, Inc.
T. Alan Russell
Geoff Shamos
Gloria & Alan Siegel
David E. Vogel
Tim Weiss
J. Michael Welsh

SUSTAINING CONTRIBUTOR
Michelle Andonian
Lawrence Armour
Phyllis & Michael
 Bamberger
Amy Banker
Dorothy Ann Blatt
Barry Burton
Margaret B. Childs
Assaf Docker
Laura Donnelley-Morton
Bradford M. Endicott
Stuart Feen
Joseph S. Fichera
Blaine V. Fogg
Rhonda S. Foreman
David Frankel
Henry Froehlich
Andrew & Bronya Galef
Mr. & Mrs. Emanuel Gerard
Jeffrey Goldstein
Mary Goodman
Arthur J. Goodwin
William C. Graustein
Geoffrey Gund
Ingrid Hansen
Aubrey & Rebeca Hill
Pieter Hoets
Michael & Jean Hoyt
Mr. & Mrs. M. Ivanitsky
Jaclyn Jeffries
Karl Katz
Mary Ann Laurans
Jonathan D. Levy
Michael Lewis
Charles Lingenfelter
The Edward A. Lozick
 Foundation
Kenneth Alan Lyon
Timothy B. Maher
Thomas A. & Diann Mann
Raymond McGuire
Lee Mellis & Yung Hee
Joyce & Robert Menschel
Brian R. Morrison
Marjorie Moss-Coane &
 James Coane
Victoria Munroe
Phil Neuman
Frank A. Parsons
David & Merle Perlmutter
Max Raab
David H. Roach
Arnold Rosenshein & Paola
 Bacchini
H. Sabarros
Hormoz Sabat
Karen Schneider
Henry Schwartz & Debra
 Perskie Schwartz
Neil Simon
Benjamin G. Slade
Kimberly K. Smith

George Stranahan
Dorit Straus
W. M. Scott Taylor
Diane Vannais & Charles
 Waldren
Mr. & Mrs. Robert Wale
Priscilla & James Warner
Chris & Nancy Welles
Christie's
Bettina & Raoul Whitteveen
Lucia & Dan Woods Lindley
R. William Youngquist

RETAINING CONTRIBUTOR
John Adlesberg
Jagdish Agarwal
John Ahearn
Evan R. Anderman
Stanley Anderson
Ronald L. Andren
David Anson
Cmurray Ardies
Dimitri Balamotis
Jon W. Balke
Alan B. Barker
Reenie Barrow
Craig Beeney
Gerard Benene
Gary H. Berquist
Neil Robert Berzak
Reis Birdwhistell
Phil Blair
Walter Bogart
Mia M. Bohn
Andrew Bollinger
John Bove
Garrett Bowden
Chuck Bowden
Philip Braun
Tim L. Buchman
Jonathan Buchter
Leonard Bulfone
Joseph & Holly Burch
Salvatore Buttiglieri
Gary A. Cain
Joaquin Cantillo
Edward Carter
Dr. Joiner Cartwright, Jr.
Joanne Clark
Edward W. Clark Jr.
Robert E. Clendenin, Jr.
Mariana Cook
Donald Cooper
Mark Danzig & Sharon Portnoy
Robert L. Davis
Lane Decamp
John Dickson
Jack L. Dietz
Gerald Duffy
Richard Dupre
Craig Eilers
Lisa Ellis
Francine G. Ellman
Karen Esler
Kendon C. Everts
David Fanta
Michael Felder
Richard L. Fenton
Warren D. Finch
Bennett Fletcher
David B. Forer
Lisa Freeman
James C. Freund, Esq.
Robert Gage

David & Gisela Gamper
Gisela Gamper
David Garfinkel
Richard T. Garner
Harom Garrin
Brent Gass
Bruce Gibb
Robert M. Gillespie
Andrew Golden
Steven Goldmann
Brian Gorman
Donald Gorman
Harry Greaver
Robert A. Gregor
Carmeda & Lawrence Gregory
Todd G. Groskopf
Melinda C. Gunson
Vikiann Gunter
Kenneth R. Hanson
Don Harbor
Clay Harmon
Peter W. Healey
HEIMO, Inc.
Ronald A. Heldorfer
Bruce A. Heyne
Erik Hillard
William C. Hoffman
Dale House
Michael Hull
Robert Hutchinson
William E. Jacobus
Christopher Jobe
Ann A. Johnson
Carl H. Josephson
Andrew Kaizer & Teresa Pesce
Bela Kalman
Drew Karandjaff
Donald M. Karp
Robert E. Kendall
Christopher Key
Jay S. Klein
William G. Knickrehm
Raymond L. Knight
Mattew R. Kokstis
Sylvan Kornblum
L. E. Kowitz
Stanley Krall
Douglas M. Kraus
Brady Kreger
Paul Krzyzanowski
L.I.S.E. Inc.
Katherine Lambert
Linda C. Lawrence
Jessica L. Ledbetter
Gordon Lee
Jean-Claude Legrand
Linda G. Lewandowski
John Loengard
William Van Loo
Linda Lubeck
Chris Lucas
Ray & Debbie Lupo
John K. MacLellan
Paul Malan
Ernst Marchel
Martin Z. Margulies
Michael N. Marks
Barry & Sara Markus
David E. Marrus
Barbara Marshall
Cloyd Masengill
Kenneth Mastin
Jeannette & Neil Matthew
Frederick M. Mayer
Sonya Mc Nair

James McGlasson
Michael L. McGraw
William McGraw
Meghan McGunness
James McLendon
Caroline Michahelles
Allen Miller
Charles Miller
Delbert L. Miller
Pete Milnes
Wayland Moore
Paul Morgan Photography
Charles Morris
Aline H. Moulton
Jill Munter
J. Michael Myers
Dale Nelson
Ardine Nelson
Cyrus E. Newitt
David Nowicki
David Obelkevich
Joseph C. Oldham
Thomas R. Osborne
T. S. Osdene
Stephen G. Oster
Melvin Osterman
Christopher & Gail Otis
D. Palermo
Robert A. Palmer
Thomas Palmer
David Parman
Andrew S. Paul
Charles Petri
Tom Pockat
W. B. Poppleton
Declan Quinn
Bob Rafelson
Luis R. Ramos
Randall R. Ranger
Mack Ray
David H. Rhinelander
Thalia Richman
Stephen Ritchie
Jay Ritter
Bobby Robinson
Matt Rodgers
Robert Rogers
Anne E. Rosen
Lewis M. Rothman, M.D.
Eric Rothstein
Irvine Rusk
Arthur Ryan
Giuliano Sargentini
John D. Sarsgard
David Schaefer
Thad Scheffel
Gil Seeber
William H. Seewald
John R. Selman
Stephen & Mary Ellen Semel
Joseph & Mildred Shady
John D. Sharpe
Kenny Sides
Jerry Siegel
Art Silbergeld
Stuart Small
Michael J. Smith
Gerardo Somoza
Timothy Spilka
Laurent Staffelbach
Warren Steinhauser
Randall Stempler
Mark Stevens
Robert Sudduth
Russ Suniewick

Michael L. Tappon
Harry Tarzian
Robert O. Taunt III
Tom Thackrey
Brad Thern
Lynn Thompson
Robert L. Thompson, Jr.
John S. Tilney Jr.
George Tilser
Charles Tompkins
Renato Tonelli
Robert H. A. Tonino
Susan Turci
Greg Twombly
Carl W. Tyler
Jeffrey Vanesky
Ricardo Vicq de Cumptich
Megan Wanlass
Michael Ward
Frederico Wasserman
Jeff Wasserman
The Waterford Institute Inc.
Karen Watson
Philip C. Weaver
Bruce A. Whittaker
John F. Wickes
Ralf Wiechmann
Arthur Williams
Eric Wiswell
Helen Wright
Donald Wright
William C. Yaroch
Charles M. Yassky
Yared Yawand-Wossen
Carlos Zavala
Fay Zinger
Lenore G. Zinn

CONTRIBUTOR
Corinne Adams
James P. Allen
Ron Allen
David Allison
Michael V. Andrews
Melvin L. Arndt
Javier Arrastia
Martha & Ernest Asten
Gregory Aubrey
Tom Ault
Arthur Axelrod
Stephen Bacon
Julian Baker
Susan Bank
Peter W. Banta
Carole W. Barbee
Edward Barrera
Rachel Barrett
C. Wrandle Barth
Soni Basi
Amy C. Bates
David Beal
Myron Beldock
David Bergholz
Dan Berley
Robert Berlinger
Gary Berman
Ruth C. Bermant
Gary Bettis
Barbara Bickford
Edna Bingham
John Blakeslee
David D. Blasczack
Sally Blommer
Thomas K. Blum
Mark A. Boeke
Sarah S. Bones

Bernie Boston
Alistair Dunn Boxwood
Alison J. Bradley
Thomas Braswell
Judith Bromley
Jorg Bruggemann
Kerry Bruns
J. P. Bryan
Lawrence C. Burgess
J. W. Burnett
Robert P. Butsic
Virginia Camfield
Stanley Campbell
Ray Campbell
F. Carapetyan
Nancy & Robert Carr
David Carrol
Gerald A. Carter
Victor M. Cassidy
Betsy Chaffin
Walter Chameroy
Stanley Chaplin
Gary Chappell
Freda Christie
Harriet Moscovic Ciccone
Dennis Clifford
Carrol W. Coffey
William J. Cofone
Richard Colburn
Michael C. Collins
George H. Colvin
Eduardo Comesana
John J. Connor II
Victor I. Covaleski
David Covert
Henry Cox
Chris J. Cox
Linda Cozzarelli
Treva Croskey
George A. Cuddeback
Edith R. Cunningham
Andrew Daecher
Michael Darter
Debra A. Davis
Homer W. Davis
Paul-Andre de Lame
Norah Delaney
Ja Densmore
Ernest DeSalvo
William S. Dickey
Terrence Diehl
John Dieter
Paul E. Dietrich
Patrick D. Dimmitt
Robert P. Dittmer
Marilyn H. Donaldson
Daryl Donley
Jim & Mary Dorskind
Paul M. Dougan
Harry M. Drake
Robert Dubinsky
Kim Duboise
John Dunivent
Sari J. Ellovich
Fred Elme
Joyce Ernst
Tommy Estridge
Mary Lloyd Estrin
Torazzi Ezio
James A. Fawcett
Thomas L. Feher, M.D.
Richard Felber
Michael Ferrante
Clive K. Fields
Fine Photos, Inc.
Mary Fish

Michael C. Forman
Ron Forth
Charles Foxwell
Gertrude C. Foy
Anne Francis
Arthur Freeman
Clare S. Freeman
Leonard W. Friede
Lawrence Friedlander &
 Elaine Rintel
Elizabeth S. Friedman
Roger Fry
Kazushi Fujita
Richard Fuller
Gary Gabler
Charles O. Garrison
Diana Garwood
J. Barry George
Michael Gerber
Carolyn Gil
Barbara Gilbert
Richard Gilles
Jan Goddard-Finegold
Susan Goldschmidt
David Goldsmith
Melinda Gordon
Michael L. Goswell
Andrew Gottesman
Karol Granger
William Graves
Daniel H. Greene
Bruce M. Greenwald
Susan Grossman
Ingo H. Grygiel
R. Gunhouse
Roland Gutierrez
Lester & Betsy Guttman
Beth Gwinn
J. E. Hackel
David Hammerton
Mark Hanauer
Scott J. Hancock
Jerilynn Hanson
Ingrid Hanzer
Willie L. Harper
Hedy Hartman
M. H. Hassan
Tony Hayden
Robert Heinecken
Jim Helman
Janice Henkind
Jonathan Heuer
John J. Hickey
Leland H. Higgins
Bruce A. Hodge
Neil A. Hoffman
Patricia Hohl
F. Rod Holt
David Hootnick
Anne Horrigan
Stephen H. Horton
Ron Hosenfeld
Juan Hovey
Edward D. Hughes
Bruce A. Ingraham
Keith Jacobshagen
J. W. Jaglo
C. Richard Jahn
Gerald E. Jensen
Jim Jipson
W. Kent Johns
Irving E. Johnson
Marc Jones
Robert Dee Jones
Susan Jorgensen
Burton Joseph

Warren B. Kanders
John A. Kane
Blan Kao
Alyssia Lazin Kapic
John B. Keillor
Mark Kelman
Barry Kessel
James A. Kipfer
Evelyn A. Knight
Patricia Knott
Leonard Korngold
Charles Koteen
Barbara Kretzschmar
Jessie Krumpen
Christie L. Lambert
Daniel J. Landiss
Ian D. Lanoff
David J. Lapin
Georgina Larkin
Lawrence A. Larson
E. Wright Ledbetter
Jennifer Lee
Susan M. Legge
Peter Legrand
Michael Lehr
Walter Leporati
Alfred Levin
Adin Levine
S. Herbert Lewis
Roger Lieberman
Phyllis Liedeker
Cynthia A. Lindquist
Victoria S. Linssen
Ronald & Ursula Long
Jean-Claude Louis
Randy Lovely
Vincent Lupinetti
Michael J. Lutch
James I. Lytton
Rita Maas
Robert Mader
Janice Madhu
Alberto Magnani
Mark Makabe
Edward P. Manley
Peter J. Manschot
Heide Marie
Lindsay & Fray Marshall
Helena Lukas Martemucci
Ian Martin
P. Wrye Martin
Steve Martin
Lynn Martin
Marcel Mathevet
Bernard & Nancy Matus
Carlin Mayer
Betsy Mc Kean
David A. Mc Collough
Thomas Mc Corkle
Steve McCormack
Kenneth L. McCoy
Gary McIntire
Besty J. McKean
Joseph Melena
George Meredith
Julie A. Mettes
Penny S. Michaels
Diana Michener
Gary Miller
Marry D. Moffly
William Monet
Isaac N. Monreal
Bruce Mooers
Melvin P. Moore
Steven C. Morris
Thomas Morton

Joseph Moscatelli
Peter Multach
Michael Mundy
Alejandro Munguia
David Nasater
W. D. Neff
Harold Nevis
W. Stephen Nixon
Thomas Nola
Andrew Norman
Donna Gray Norquist
Kiku Obata
Samuel L. Olfano
Dana Osborn
Detlef Ott
David Papuga
Raymond M. Pearsall
Donald P. Penta
James A. Pepperl
Ron Perisho
Peter Pflasterer
James T. Pletcher
Pam Fred Ploeger
Leslie Pollack
Burt & Babette Posepki
Elizabeth A. Preston
David J. Purchase
Harold O. Purvine
Jesse C. Rabinowitz
John Raines
John Raleigh
Robert Rauschenberg
Freddy Rayes
C. W. Reiquam
Jerold W. Reis
Alan M. Reisch
Richard Rembisz
Alfred Rendon
Ruth & James Reynolds
James Rhem
Shelby D. Rifkin
Robert B. Ritley
Christopher T. Ripley
Rossana Rizzo
Seth Roberts
Alice Robertson
J. Robinson
Ford Rogers
Daniel Root
David Roth
Howard C. Royce
Johns F. Rulifson
David C. & Sarajean
 Ruttenberg Arts Foundation
Denis Ryan
Jon L. Saari
Dr. & Dr. John P. Schaefer
Laurie Schaefer
Eric Scharin
Carlos Schenck
Katherine Schmidt
Brian D. Schneider
Paul T. Schnell
Mary Anne Schrank
David N. Schwartz
Robert Scwartz
Ben Segal
Louise Serpa
David A. Shaw
Barbara Lee Shaw
Marianne Sheedy
Jim Sheen
Douglas Sherburne
John Sherman
Jay M. Short
Stan Short

Bruce D. Shriver
Albert de Silver
Al Simon
Craig Sisson
James Smith
Wesley Smith
Carol A. Smith
Richard A. Smith
George W. Smuckel
Mel Smyre
Ken Sontheim
Jay D. Sorenson
Omer Franklin Spurlock
Thomas S. Stalder
Carl Steele
Paul Stetzer
Thomas Stoffregen
Martin M. Stone
Noreene Storrie
Lynard P. Stroud
Jon Stuart
Jonathan Stuart
Robert Sutherland
Marla Sweeney
Duncan B. Taylor
Mark Taylor
Anthony Teresi
Raymond A. Thorne
Joseph & Jennifer Thurn
Gerard Tieman
David Toal
Cardi S. Toellner
Robert Tomsak
Barry Toranto
Virginia Tougas
Eileen Toumanoff
Peter Treadwell
Robert Trongone
Leroy Tschida
Wendy J. Tyson
U-Develop
Carlos Vasquez
Bruce Weltman
Sterling Vinson
Neils & Irmlein Waehneldt
Mary Joan Wale
Jan C. Watten
Lannie D. Webb
Alexander Weiner
Claire Weiss
Samuel & Judith Weiss
Gerald Wenner
Edward P. Wheeler
Pg Wiegman
Robert J. Wilson
Wilma Wong
Raymond Woodhouse
James Wright
David J. Wyckoff
Michael & Nancy Wyland
James Wynd
Marilynn K. Yee
Morden Yolles
Doug Yoshida
Dennis Yusa
James Ziefert
Jon Ziegler
Frank E. Zipperer